JONVELLE

JONVELLE

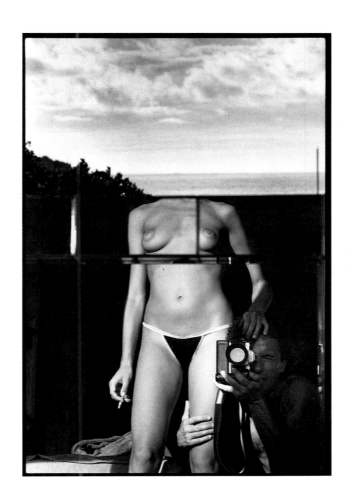

© 1989 Éditions Nathan, Paris
© 1997 Éditions de La Martinière, Paris

© 1997 for this edition
Könemann Verlagsgesellschaft mbH
Bonner Str. 126, D–50968 Köln

Translation into English: Paul Aston
Translation into German: Charlotte Ronsiek
Typesetting: Claudia Faber
Layout: Benoît Nacci
Reproductions: Jovis, à Cachan
Printing: Kapp, Lahure Jombart à Évreux

Printed in France
ISBN 3-8290-0008-1

An Intimate Mini-ABC of Jean-François Jonvelle

Compiled by Sylvie Milhaud

Kleines persönliches ABC von Jean-François Jonvelle

Bearbeitet von Sylvie Milhaud

AVEUX

CONFESSIONS I was born in Cavaillon, France in 1943. I was quite a noisy brat. My birth sign was Libra. Mother and Father were both kinesitherapists, whereas I excelled mainly as a dunce at school! My boarding school—the Christian brothers at Sens—didn't really improve things... It was a local photographer who initiated me into photography by inviting me to join him on a cathedral Tour de France. Thanks to this man, at sixteen I was a maker of images.

Ich wurde 1943 in Cavaillon, Frankreich geboren. Als Baby war ich ein rechter Schreihals. Sternzeichen Waage. Mama/Papa waren beide Krankengymnasten und ich—vor allem faul in der Schule! Auch im Internat bei den Christlichen Brüdern in Sens hat sich das nicht wesentlich gebessert... Zur Photographie kam ich durch einen freischaffenden Photographen aus meiner Heimatgegend. Er lud mich ein, ihn auf eine Kathedralen-Reise durch Frankreich zu begleiten. Diesem Mann verdanke ich es, daß ich mit sechzehn Jahren zum Bildermacher wurde. **GESTÄNDNISSE**

BONHEUR

LUCK Having had my finger on the photo button so young and been able to tell myself every morning that, no, I wasn't mistaken, quite the contrary—I was privileged. Really. Today I'm a craftsman who loves his job, with the same conviction, the same enthusiasm and as much force of passion as I had from the first. It's been my luck never to have shackled my freedom or lost my freshness, or my instincts. I'm perpetually on the watch, ready to photograph anywhere, any time, ready to seize the moment. My only motto—"do everything unimaginably!"

Daß der Auslöser für meine Photobegeisterung so früh gedrückt wurde und ich mir jeden Morgen sagen kann—ich habe mich nicht getäuscht, ganz im Gegenteil—das ist das eigentliche Glück meines Lebens. Bis heute bin ich ein Handwerker, der seinen Beruf liebt: mit derselben Überzeugung, derselben Begeisterung und ungebrochener Leidenschaft. Glücklich bin ich auch darüber, daß ich meine Freiheit nie beschnitten, meine Frische und meinen Instinkt nie verloren habe. Ich liege stets auf der Lauer, bereit, überall und immer abzudrücken, bereit, jede sich bietende Gelegenheit zu nutzen, geleitet von einer einzigen Devise: »Alles außerordentlich zu machen!« **GLÜCK**

CUL

ARSE Traveling upwards along the legs, the image is in slow motion, ascending to her arse . The girl turns, and our eyes meet. At that moment, the image freeze-frames and, ohmygod, a fury of bibble-babble, lead in my bowels, the divine bolt, throbbing, seduction, desire, delight, love... And what about provocation, then?

Travelling nach vorne auf die Beine, das Bild in Zeitlupe, dann weiter hoch zum Arsch. Die junge Frau dreht sich um, unsere Blicke begegnen sich. In diesem Augenblick bleibt das Bild stehen. Großes Durcheinander, Gestammel, der Magen zieht sich zusammen, Liebe auf den ersten Blick, Trieb, Verführung, Verlangen, Lust, Liebe... Wo bleibt da die Provokation? **ARSCH**

CINEMA (my own) — I always work alone when I'm making photos for myself. Like those for this book I prepare nothing, but am in a state of receptiveness, of living the moment intensely. And then I fire off till I ache. My movie is the well-struck phrase, attitudes, more words...

Wenn es mir—wie für dieses Buch—darum geht, sehr private Photos zu machen, arbeite ich immer alleine. Dafür bereite ich nichts vor, bin aber in einem Zustand, der mich offen macht, den Moment intensiv zu erleben. Und dann knipse ich bis zur Erschöpfung. Mein Kintopp: die richtigen Worte, Haltungen, und nochmals Worte... — KINO (mein eigenes)

CINEMA — All my feelings come from films. Films are my native broth, my homeland, my whole culture... For four years, I went to the film library every day, to see Mankiewicz, Lubitsch, Fritz Lang, Orson Welles, Arthur Penn, every Minelli and Hitchcock, Marcel L'Herbier and Tourneur. Some time back I really wanted to make a film myself but, frankly, I know I'm not yet done with my photographic trip.
P.S. My all-time favorite film: *Jules et Jim* by François Truffaut.

All meine Gefühle kommen vom Kino her. Das Kino ist mein Kraftfutter, meine Heimat, meine ganze Kultur... Vier Jahre lang bin ich jeden Tag in die Filmothek gegangen, um mir Mankiewicz, Lubitsch, Fritz Lang, Orson Wells, Arthur Penn, alle Minnellis und Hitchcocks, Marcel L'Herbier und Tourneur anzusehen. Vor einiger Zeit überkam mich tatsächlich die Lust, selbst einen Film zu drehen. Im Grunde meines Herzens weiß ich aber, daß ich mit der Photographie noch längst nicht abgeschlossen habe.
P.S. Mein Lieblingsfilm: *Jules et Jim* von François Truffaut. — KINO

WEAKNESSES — I'm lazy, impatient, timid, a mite slow to cast off in the mornings. On the other hand, I'm not a liar, but an ace at the dummy pass. On the battlefield, I'm not sure I'd be there in the front line. In short, not the soul of a hero!

Ich bin faul, ungeduldig, schüchtern und komme morgens eine Spur zu langsam in Gang. Ich bin nicht verlogen, sondern besitze lediglich die Fähigkeit, Körper zu verzaubern. Ob ich auf einem Schlachtfeld an vorderster Front marschieren würde? Ich weiß es ich nicht; das Zeug zum Helden habe ich nicht! — FEHLER

EMOTION — The eyes have it. Eyes which speak without speech, a handshake, an inch of skin, a tone of voice, surrender. Mix with a dash of perversity, three doses of vulnerability and an overdose of tenderness. That's what I offer!

Der Blick ist alles. Augen, die sprechen, ohne daß geredet wird, ein Händedruck, eine Haut mit ihrer ureigenen Struktur, der Klang einer Stimme, Gelöstheit. Geben Sie dann noch einen Schuß Perversion, drei Prisen Verletzlichkeit und eine Überdosis Zärtlichkeit hinzu, so wissen Sie, was ich anzubieten habe! — GEFÜHL

WOMAN — If she's wearing torn jeans, chewing gum or wired to a Walkman, she's not exactly my heroine. Sensual, vulnerable and trusting is how I want her. My ideal is Silvana Mangano at twenty, or Ingrid Bergman. Desperately seeking Grace Kelly as well. To fashion her to my image.

Wenn sie eine zerrissene Jeans trägt, Kaugummi kaut, einen Walkman umhängen hat, so entspricht sie nicht ganz meiner Traumfrau. Ich will sie sinnlich, verletzlich und voller Vertrauen. Mein Ideal: Silvana Mangano mit zwanzig oder Ingrid Bergman. Auch Grace Kelly verzweifelt gesucht... um sie nach meinem Bilde zu formen. — FRAU

GAMELLE (s'en prendre une)

GAFFE A flop is when I take a photo I feel I really like and the girl isn't comfortable with it.

Ein Fiasko ist, wenn ich das Gefühl habe, ein Photo gemacht zu haben, das mir wirklich gefällt, und sich die Frau darauf nicht leiden kann. AUF DIE NASE FALLEN

HARPER'S BAZAAR

HARPER'S BAZAAR I really got started with fashion photos. That was for *Harper's Bazaar*, thanks to the photographer Richard Avedon. I was fascinated by a series of black and white photos he did for the magazine with Ava Gardner and Mike Nichols. Smitten with enthusiasm, I naively wrote to him gushing admiration, at the following address: Richard Avedon, *Harper's Bazaar*, New York, USA. Three weeks later, I got a reply! "Come to Hotel San Regis in Paris on such and such a day at such and such a time." That's how I came to find myself, at eighteen, acting as his assistant for a month. At the time, the Master was working with the topmost of top models, Jean Shrimpton and Twiggy. He taught me to strip the mystique out of technique by keeping it simple and talking to the girls, so they made the best of themselves. After that, for me, things really took off, very quickly, very steadily: *Jardin des Modes, Elle, 20 Ans, Nova...*

Wirklich los ging es bei mir mit der Modephotographie, und zwar für *Harper's Bazaar*. Das verdanke ich dem Photographen Richard Avedon. Fasziniert von einer Reihe Schwarzweißphotos, die er mit Ava Gardner und Mike Nichols für diese Zeitschrift gemacht hatte, schrieb ich ihm voller Begeisterung und Naivität, um ihm meine ganze Bewunderung auszudrücken. Den Brief richtete ich an folgende Adresse: Richard Avedon, *Harper's Bazaar*, New York, USA. Drei Wochen später erhielt ich eine Antwort! »Kommen Sie an dem und dem Tag um die und die Uhrzeit ins Hotel San Regis in Paris...« Und so kam es, daß ich mit achtzehn Jahren einen Monat lang Assistent bei ihm war. Der Meister arbeitete damals mit den Top-Spitzenmodels: Jean Shrimpton und Twiggy. Er lehrte mich, die Technik zu vereinfachen und sie dadurch zu entmystifizieren. Er lehrte mich, mit den Mädchen zu sprechen, um das Beste aus ihnen herauszuholen und zur Geltung zu bringen. Danach ging es für mich sehr schnell steil aufwärts: *Jardin des Modes, Elle, 20 Ans, Nova...* HARPER'S BAZAAR

HOMME

MAN I don't turn spontaneously towards men, I admit. The only man whose presence will be noticed in this book is—I hope—me! I'm far too jealous to allow any others... But I really would like one day to have carte blanche to photograph the Pope, in my own way.

Auf Männer gehe ich nicht spontan zu, das ist richtig. Den einzigen, den man—hoffentlich—in diesem Buch entdecken wird, ist meine Wenigkeit! Dazu bin viel zu eifersüchtig... Und dennoch, die freie Hand, den Papst auf meine Art zu photographieren, hätte ich trotzdem eines Tages gern. MANN

IMAGE

IMAGE My mind is stocked with forceful images. The most magical: the first man on the moon. The most terrifying: hostages being seized at the Libyan Embassy in London, filmed live for television. The most shameful: the train derailed outside the Gare de Lyon in Paris, with morbid onlookers using the occasion to make faces at the camera...

Ich habe einen ganzen Vorrat wichtiger Bilder im Gedächtnis. Das magischste: der erste Mensch auf dem Mond. Das schrecklichste: eine Geiselnahme in der libyschen Botschaft in London, live fürs Fernsehen gefilmt. Das schändlichste: der entgleiste Zug im Bahnhof von Lyon, den Schaulustige dazu benutzen, um in die Kamera zu winken... BILD

JONVELLE

JONVELLE As I talk quickly and don't articulate properly, people find it difficult to understand me on the phone. So I always say "Jonvelle with a 'J' as in joie de vivre."

Da ich schnell und undeutlich spreche, verstehen mich die Leute schlecht am Telefon. Deshalb sage ich immer: »Jonvelle mit ›J‹ wie Jauchzen«. JONVELLE

KALEIDOSCOPE | Sometimes several of my photos have been brought together for exhibitions. The first took place in 1983 in a gallery on the Ile Saint-Louis. They were photographic bits and pieces displayed in a rather aimiable jumble which attracted a frightful scrum on the evening of the private view. Two years later, in London, Hamilton's Gallery devoted a smart retrospective to me, and a vineyard specially baptized a cuvée of 400 bottles of Meursault for the occasion. And in 1986, at St Lazare station Paris, 35 of my photos were displayed on boards 6 foot wide and 10 foot high which nigh on 50,000 people could see every day. Even so, some brawny smart Aleck still managed to pinch them!

Es ist vorgekommen, daß einige meiner Photos in Ausstellungen zusammengetragen wurden. Zum ersten Mal 1983 in einer Galerie auf der Ile Saint-Louis. Das war alles alter Kram, Abzüge, die in einer eher glücklichen Unordnung daherkamen und zur Vernissage eine Unmenge Leute anzogen. Zwei Jahre später widmete mir die Hamilton's Gallery in London eine hochvornehme Retrospektive, bei der ein Winzer eigens eine Cuvée von 400 Flaschen Meursault taufte. 1986 wurden dann 35 meiner Photos im Bahnhof Saint-Lazare auf zwei Meter breiten und drei Meter hohen Plakatwänden aufgehängt, die jeden Tag für 50.000 Personen zu sehen waren. Ein ganz cleverer, stämmiger Kerl hat es sogar geschafft, sie zu klauen! | KALEIDOSKOP

LIGHT | Light colors a photo and endows it with a soul. I search for it and always define it with the inside of my hand. That's my very own grading and my cunning craftsman's technique to coax forth the best result.

Licht gibt einem Photo Farbe und Seele. Ich suche es immer, bevor ich es dann an meiner Handfläche definiere. Das ist mein ureigenes Eichmaß, meine handwerklich sichere Technik, um ganz nah dran zu sein. | LICHT

MOTHER GRANDMA MY SISTER | My first consenting victim was my little sister. I photographed her from every angle. Mama was the second, and Gran had the place of honor in my first book *Celles que j'aime* (Those I Love).

Mein erstes und ständiges Opfer war meine kleine Schwester. Ich habe sie aus allen auch nur erdenklichen Blickwinkeln photographiert. Mama war die zweite. Und Oma kam in meinem ersten Buch *Celles que j'aime* (Die ich liebe) zu Ehren. | MAMA OMA MEINE SCHWESTER

PEEPING TOM | It's true I'm always observing, everywhere. But then I'm never bored. It's something of a professional vice, but a real pleasure as well. In fact, observing is a kind of third eye.

Es stimmt, daß ich immer und überall Leute beobachte. Dadurch langweile ich mich nie. Das ist wohl ein bißchen berufsbedingt, macht aber auch richtig Spaß. Für mich ist beobachten tatsächlich mein drittes Auge. | SPANNER

NATURAL | I like girls when they are natural and spontaneous. I like, for example, to dampen their hair slightly, or let it down. When I started, I remember throwing glasses of water in their faces to force them to react naturally. Too much make-up usually makes faces dull, not to say ugly. How could anyone want to kiss a girl who's plastered with lipstick? And the surroundings must suit the mood of the girl, too. I shun any kind of pretence, anything that smacks of

Ich mag Mädchen, die natürlich und spontan sind. Mir gefällt es zum Beispiel, ihnen die Haare etwas naß zu machen und ihre Frisur durcheinander zu bringen. Ich erinnere mich an meine Anfangszeiten; da schüttete ich ihnen ein Glas Wasser ins Gesicht, um sie zu zwingen, natürlich zu reagieren. Zuviel Schminke wirkt meist schwerfällig und macht die Mädchen eher häßlicher. Wie kann man Lust verspüren, ein Mädchen zu küssen, das kiloweise Lippenstift aufgetragen hat? | NATÜRLICH

false flashiness or sophistication. To create, I need an atmosphere of truth. I like the light which embraces a girl when she wakes up, just after a caress. Don't you?

Die Stimmung muß mit dem Mädchen im Einklang sein. Ich meide alles Aufschneiderische, alles, was protzig oder gekünstelt daherkommt. Um kreativ zu sein, brauche ich eine ehrliche Atmosphäre. Ich liebe das Licht, wenn es ein Mädchen beim Aufwachen streichelt... gleich nach einer Liebkosung. Sie nicht?

NOIR ET BLANC

BLACK AND WHITE — Things must be written black on white, and photos are the same. That's the choice I made for my intimate, personal handwriting. I sometimes add a touch of color, to bring out a contrast or enhance a detail, but this is still only a nuance drawn from the palette of black and white. Color is sometimes useful on a detail of skin or in a gaze. And if I have chosen to do this book like that, it is because these are my preferred tones. But for commissioned work (a fashion photo, publicity, etc), I obviously use color, and enjoy doing so. Nevertheless, as soon as I'm back on a personal job, I enclose myself in black and white again.

SCHWARZWEISS — Eine Aussage muß schwarz auf weiß stehen, ein Photo auch. Das ist die Sprache, die ich als meine ganz persönliche Ausdrucksform gewählt habe. Manchmal, um ein Relief zu modulieren oder ein Detail zu unterstreichen, füge ich eine leichte Färbung hinzu, die aber eigentlich nur eine Nuance aus der Palette zwischen schwarz und weiß ist. Das kann bei einer Hautstruktur oder einem Blick hilfreich sein. Wenn ich mich entschieden habe, dieses Buch genau so zu machen, dann deswegen, weil es sich hier um meine Lieblingstöne handelt. Für Auftragsarbeiten (Modephotos, Werbung...) hingegen setze ich selbstverständlich und gerne Farben ein. Das ändert aber nichts daran, daß ich mich dann wieder ganz dem Schwarzweiß hingebe, sobald ich zu privateren Arbeiten zurückkehre.

OBJECTIF

LENS — I always use the same lens for my Nikon, namely an 85 mm. This is the one that allows me to capture what I see as closely as possible. That registers what my eyes register. Because, really, it ought to be my eye which presses the button. The camera often seems to me like a carapace.

OBJEKTIV — Bei meiner Nikon benutze ich immer dasselbe Objektiv: 85 mm. Damit kann ich das, was ich sehe, am genauesten wiedergeben. Dieses Objektiv ist meinem Blick am treuesten. Im Grunde wünschte ich mir, man könnte mit dem Auge klick-klick machen. Der Photoapparat kommt mir oft wie ein Barriere vor.

PUBLICITÉ

ADVERTISING — I first began to do advertising campaigns in the 1970s. Levi's jeans fired the starter's gun. Of all those I've done, my favorites are Banga, Huit, Club Méditerranée, Myriam, Dunlopillo, Galeries Lafayette, Yop, Mobalpa... I find it a very taxing form of visual gymnastics. I came from fashion, which is a wholly different world. Conditions were quite different in advertising. They taught me to be terribly demanding and infinitely selective in what I chose: light, casting, style, setting, etc.

WERBUNG — Meine ersten Werbekampagnen gehen auf die 70er Jahre zurück. Der eigentliche Startschuß war dann die Kampagne für Levi's Jeans. Am liebsten von allen, die ich je gemacht habe, sind mir die für Banga, Huit, Club Méditerranée, Myriam, Dunlopillo, Galeries Lafayette, Yop, Mobalpa... Für mich ist das eine unerhörte Augengymnastik. Ich kam ja von der Mode her, aus einer anderen Welt. In der Werbung mußte ich dann ganz neue Anforderungen erfüllen und lernte, äußerst anspruchsvoll und wählerisch in meinen Entscheidungen zu werden: Licht, Casting, Design, Inszenierung...

PHOTOGÉNIE

PHOTOGENIC — See X (Mrs)

Siehe X (Madame)

PHOTOGEN

WHEN — Any time. The girls are the same, my way of working is the same, my photos are, I believe, the same. Time hasn't budged for me, the 1970s were scarcely yesterday.

Immer. Die Mädchen sind die gleichen, meine Art zu arbeiten ist die gleiche, meine Photos sind—glaube ich—die gleichen. Für mich ist die Zeit nicht vergangen; die 70er Jahre... fast wie gestern. — **WANN**

LAUGHTER — Laughter has helped me gain a lot of time with women. And humor always has me doubled up. My thanks to Peter Sellers for all those insane laughs...

Lachen hat mir mit den Frauen viel Zeit erspart. Und Humor ist für mich etwas Unwiderstehliches. Peter Sellers sei Dank für die Lachanfälle... — **LACHEN**

BATHROOM — Bathrooms are, more than any other, places of intimacy, and I love working in them as much as I love being alive. They should be roomy, well-lit and comfortable enough to make you want to spend hours in them. Even if I haven't shown it in the book, I like photographing girls there, because the very fact of being in this room makes them confident and relaxed. A vital place, it's my preferred studio because attitudes are "desophisticated" in it. And, to be quite frank, it is true that bidets are one of my fantasies!

Ein Badezimmer ist ein intimer Ort par excellence. Ich arbeite und lebe dort gleichermaßen gern. Es muß geräumig, hell und so bequem sein, daß man Lust hat, lange darin zu verweilen. Auch wenn ich das Bad auf dem Bild nicht als Rahmen sichtbar mache, photographiere ich die Mädchen gerne dort, denn hier gewinnen sie Vertrauen und entspannen sich. Badezimmer sind Orte des Lebens und mein bevorzugter Arbeitsplatz—weil sie »entkünstelnd« wirken. Ganz im Vertrauen: auch das Bidet gehört zu meinen Phantasien. — **BADEZIMMER**

FUNK (death of) — I hate showing I'm in a funk, but having it excites me rather like a bonus motivation. The rare times I haven't been in a funk, I haven't done my work well. Fortunately, that hasn't happened very often. And if it stopped happening, I'd give this job up.

Ich hasse es, Lampenfieber zu zeigen. Aber wenn ich es habe, wirkt es eher anregend... wie eine zusätzliche Motivation. Die wenigen Male, bei denen ich keines hatte, fiel meine Arbeit schlecht aus. Glücklicherweise war das nicht oft der Fall. Wenn ich kein Lampenfieber mehr hätte, würde ich mit diesem Beruf Schluß machen. — **LAMPENFIEBER (sterben vor)**

EMERGENCY — A quarter of Vittel costs 15 francs, a glass of red wine 3.50 francs. Something of a problem, isn't it.

Ein Viertel Vittel-Wasser kostet 15 Franc, ein Glas Rotwein kostet 3,50 Franc. Da gibt's doch irgendwie ein Problem, oder? — **NOTSTAND**

TRAVELS — Adventures—setting off—encounters—smells—noises—cohabitation—revelation of personality—distortion of time—I hate picture postcards.

Abenteuer—Wegfahren—Begegnungen—Gerüche—Geräusche—Vereinigung—Entwicklungsbad für die Persönlichkeit—Zeitverzerrung—Ich hasse Ansichtskarten. — **REISEN**

WEEK-END

WEEKEND I don't know what weekend means because obviously I work any day. But if a great vista of free time opens up, I plug in my answerphone, mislay my watch and dive into a sordid siesta. Afterwards, I make up a plethora of imaginary things to do, and there's always a real one which crops up. To empty my head, I enjoy cooking for my friends and even doing some proper housework.

Ich weiß nicht, was Wochenende ist, denn selbstverständlich arbeite ich ganz gleich an welchem Tag. Aber wenn ich etwas freie Zeit vor mir habe, stelle ich den Anrufbeantworter an, vergesse meine Uhr und tauche ab ins Lotterbett! Danach denke ich mir einen Haufen falscher Dinge aus, die zu machen wären, und immer kristallisiert sich irgendwann ein einzig richtiges heraus. Um den Kopf frei zu bekommen, koche ich gern für Freunde oder mache auch mal einen richtigen Großputz. WOCHENENDE

X (M^me)

X (Mrs) Everyone can be photographed. To take Mrs X and bring out what isn't obvious about her is an additional challenge which really buzzes me. It gives me a kick to break open prefabricated molds and reveal unexpected expressions, attractions or attitudes. And that is valid for models as well, because sometimes they have so-called beauty mannerisms that pervert their personalities and with which I'm always contending.

Jeder Mensch ist photographierbar. Madame X aufzunehmen und dabei genau das zu unterstreichen, was an ihr nicht gleich offensichtlich ist: darin liegt eine weitere Schwierigkeit, die mich wirklich motiviert. Ich liebe es, vorgegebene Formen zu verlassen, damit ein Ausdruck, eine Ausstrahlung, eine Haltung herauskommt. Das gleiche gilt übrigens auch für weibliche Models: manchmal haben sie Macken, die angeblich voller Schönheit sein sollen; sie verfälschen aber die Persönlichkeit, und deshalb bekämpfe ich sie hartnäckig. X (Madame)

YÉ-YÉ

YEAH-YEAH-YEAH It was to the music of Paul Anka and subsequently the Beatles that my love life began. Oh the stupidity and tears of thinking oneself deeply in love with a girl...

Die Musik von Paul Anka und die der Beatles steht für mich für meine ersten Flirts. Damals vergoß man künstliche Tränen, wenn man meinte, ganz schrecklich in ein Mädchen verliebt zu sein... YE-YE-YE

ZOOM

ZOOM I think using a zoom is easy. That's not one of my dodges.

Ein Zoom zu benutzen, scheint mir zu einfach. Das ist nicht mein Ding! ZOOM

THE END!
NO,
NEVER!
(Sacha Guitry)

ENDE!
DAS
NIEMALS
(Sacha Guitry)

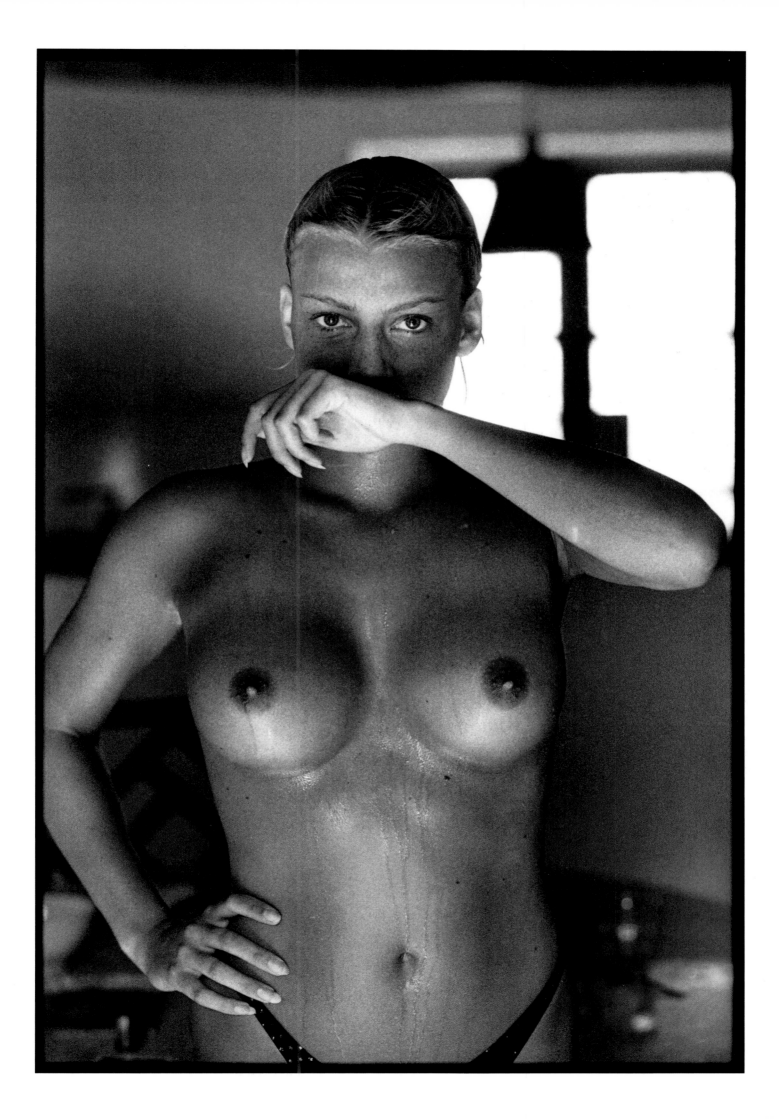

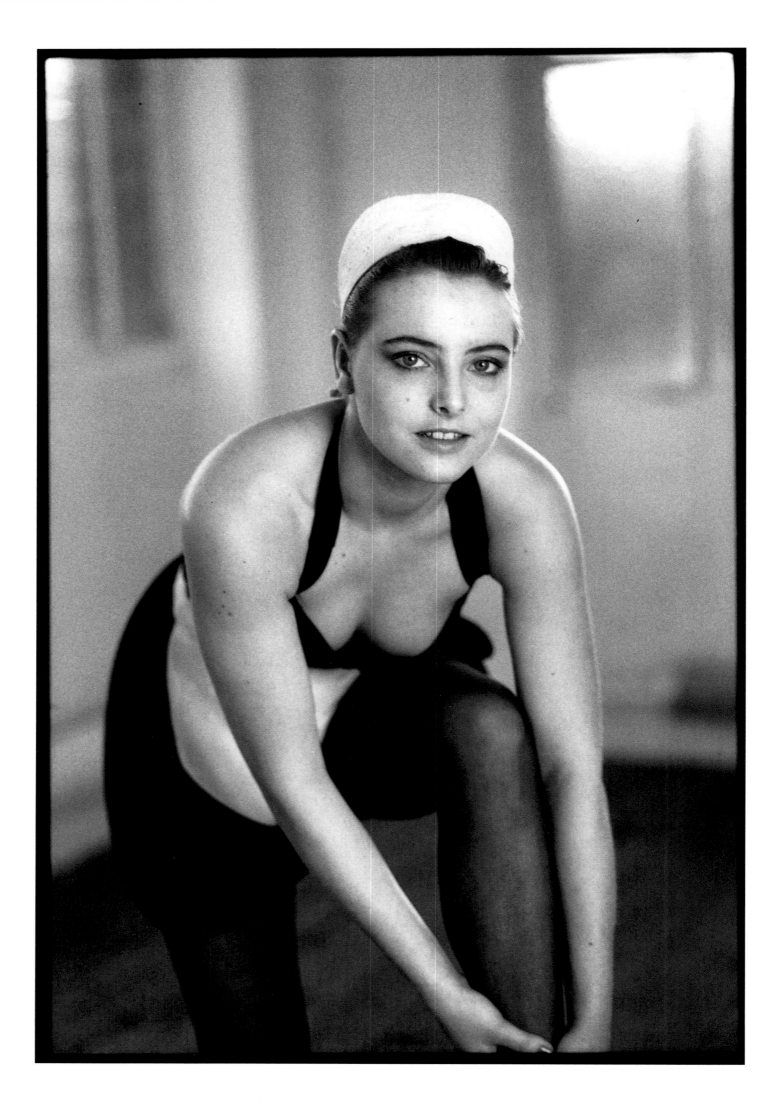

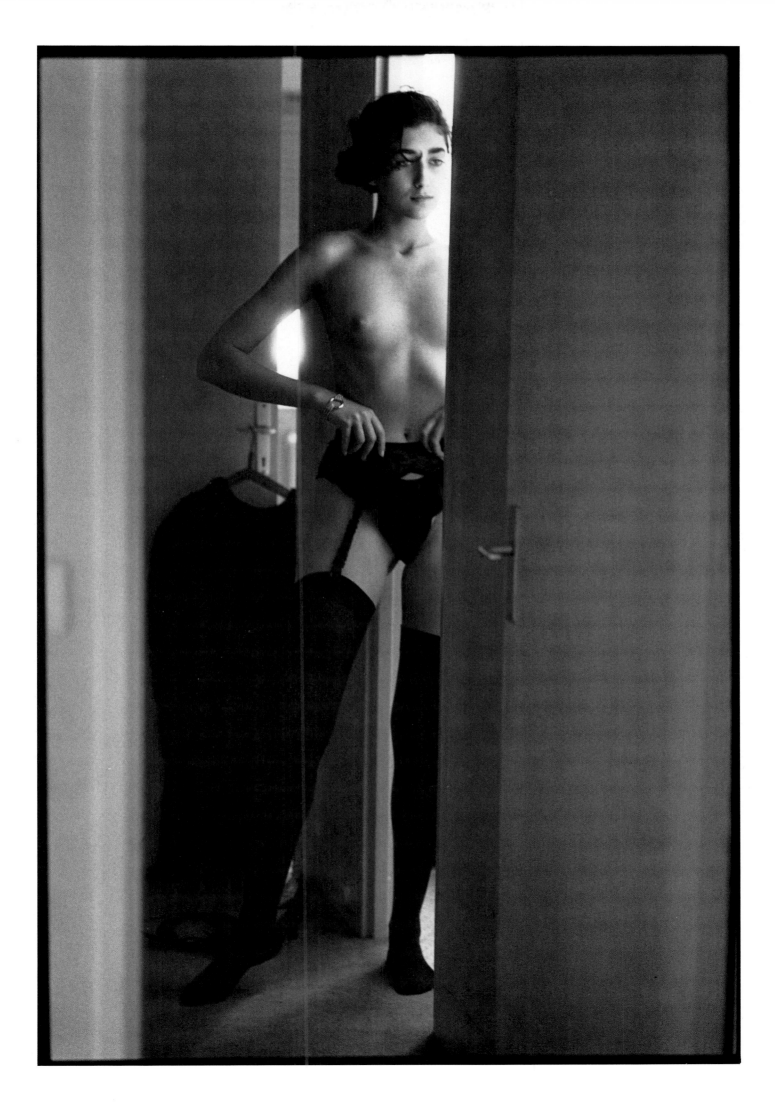

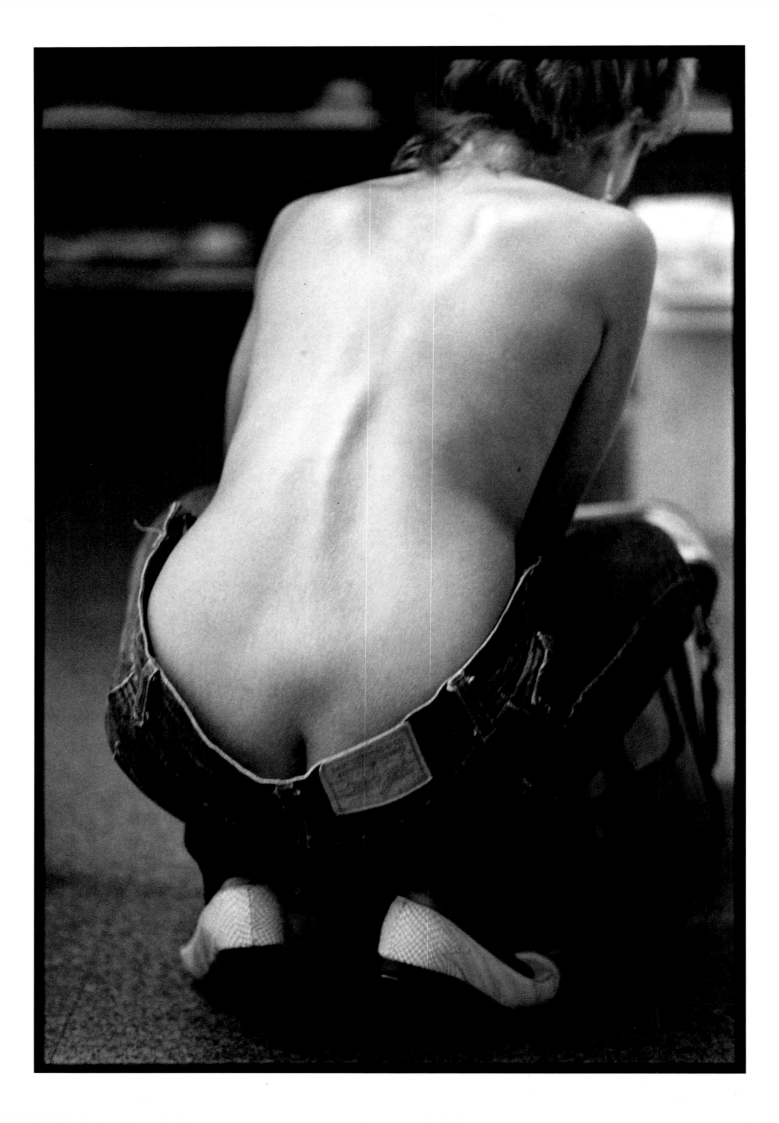

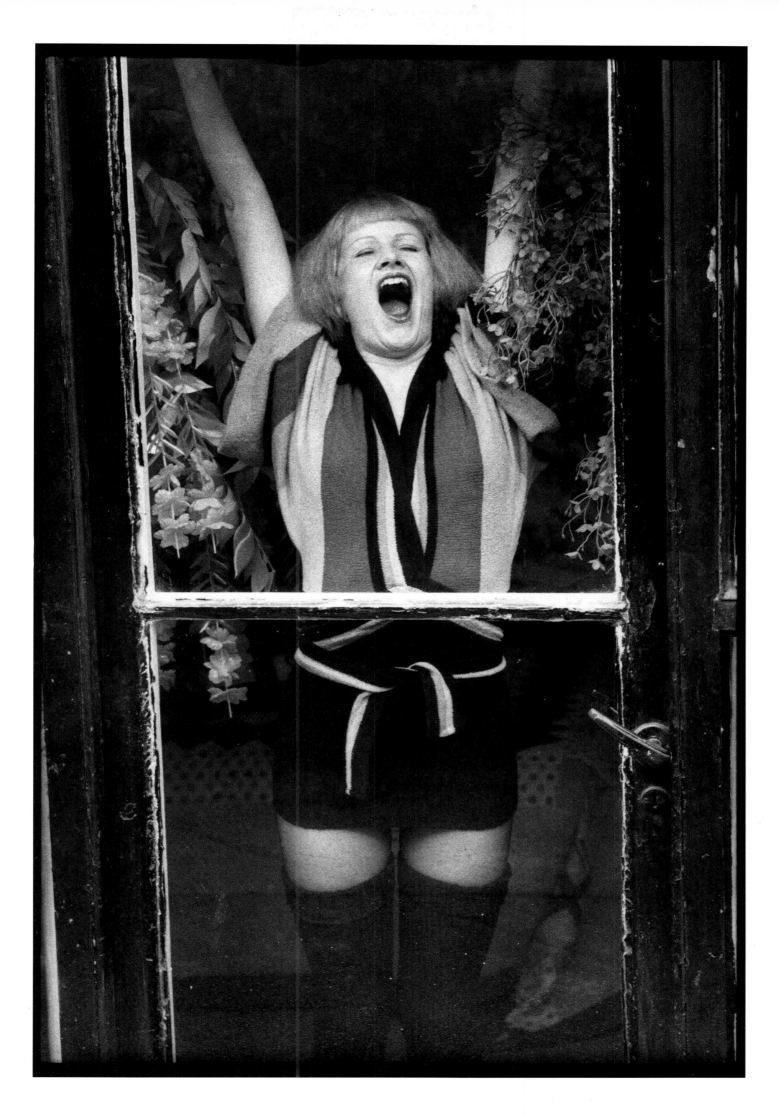

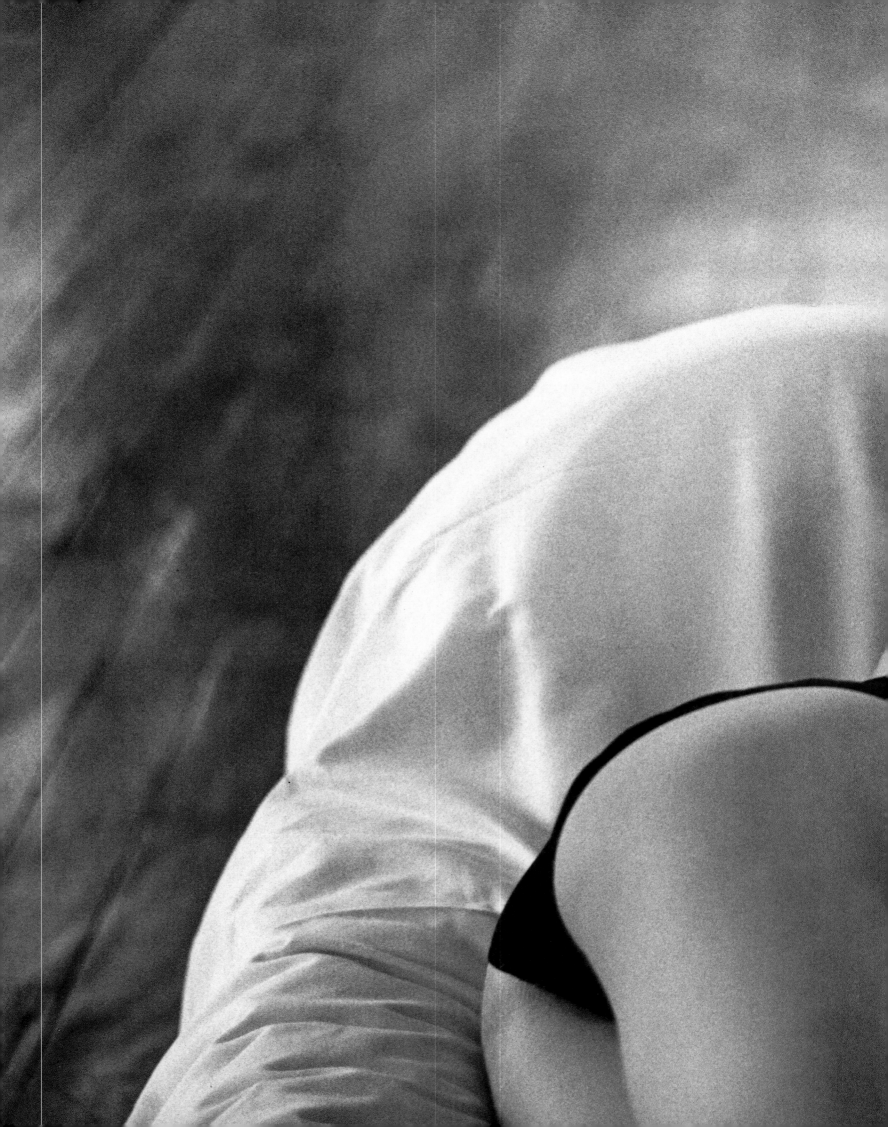

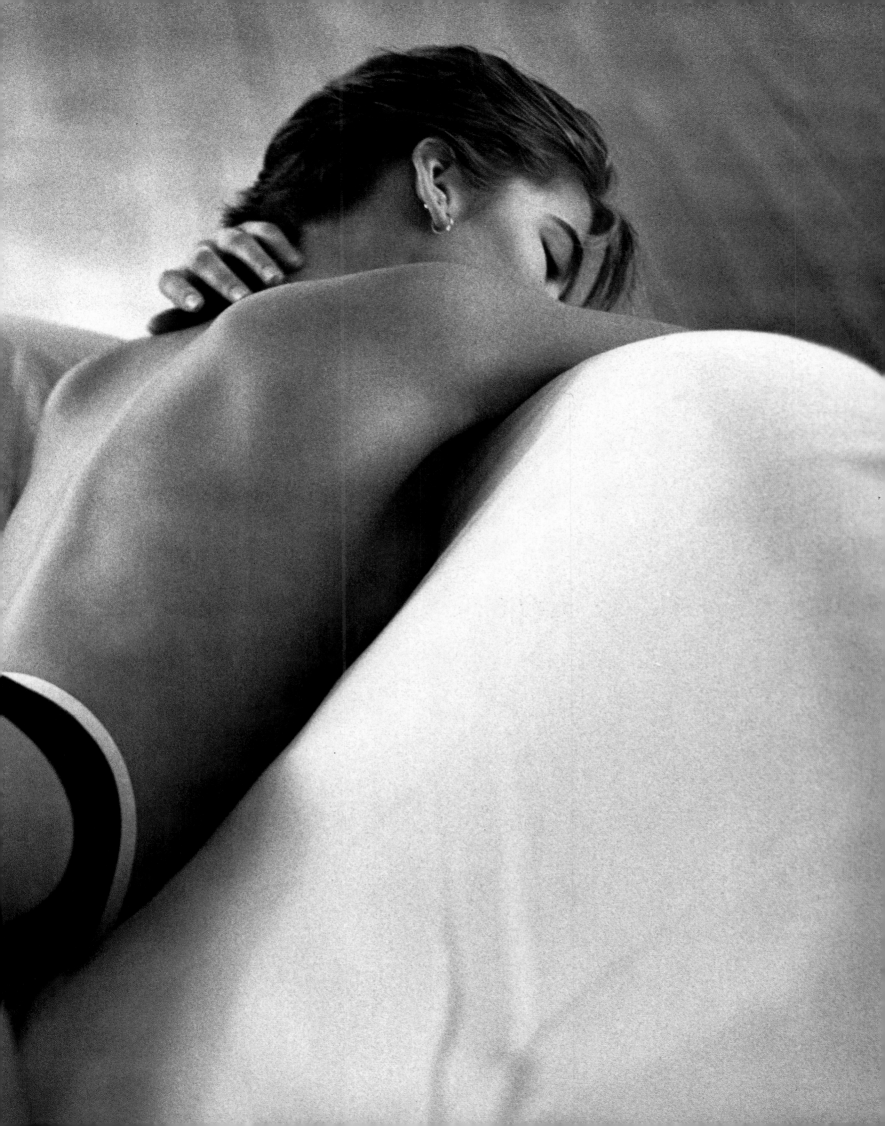

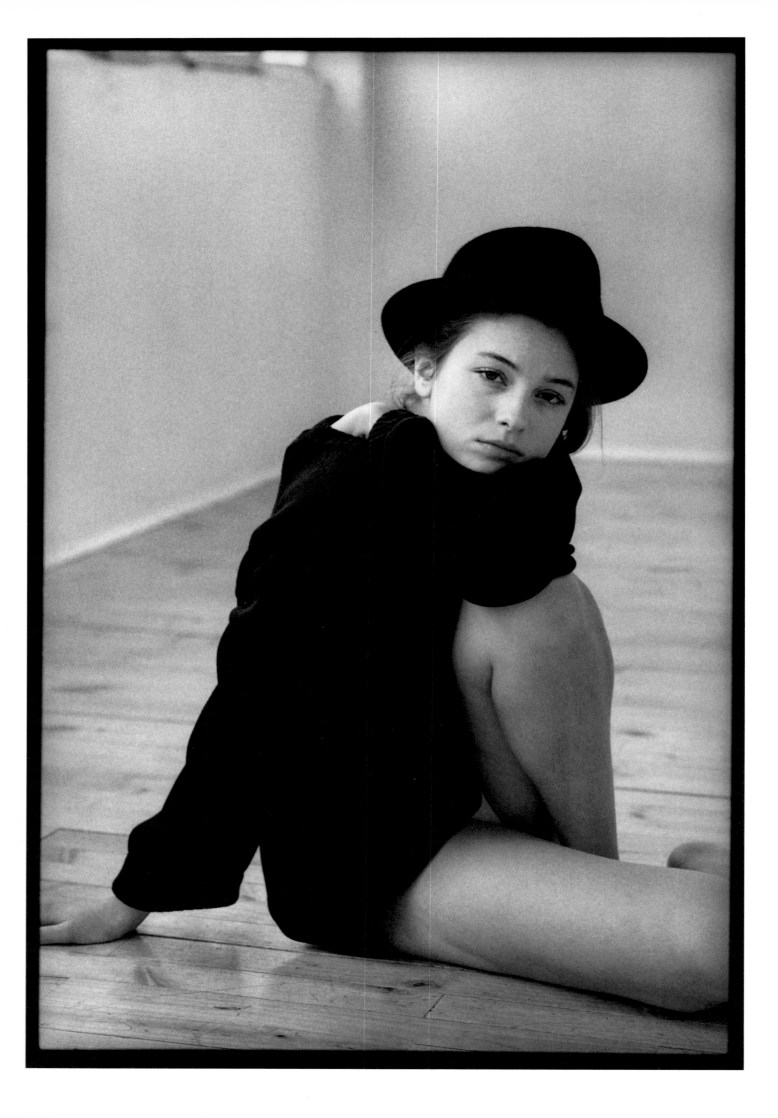

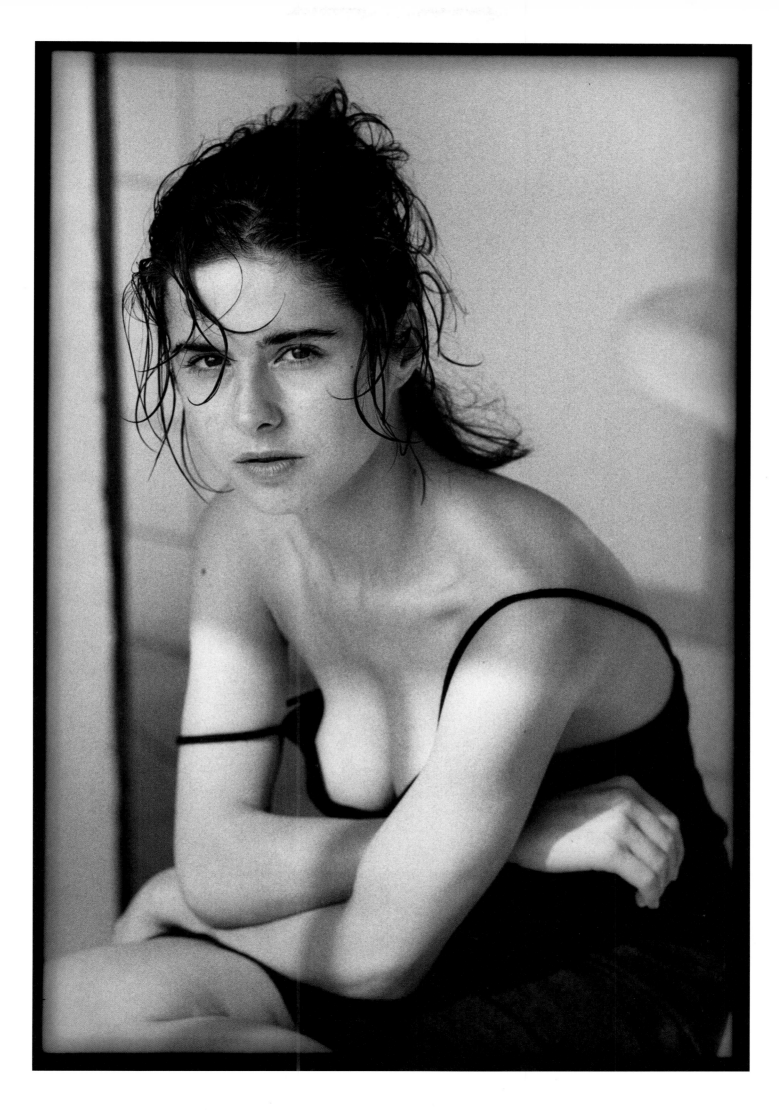

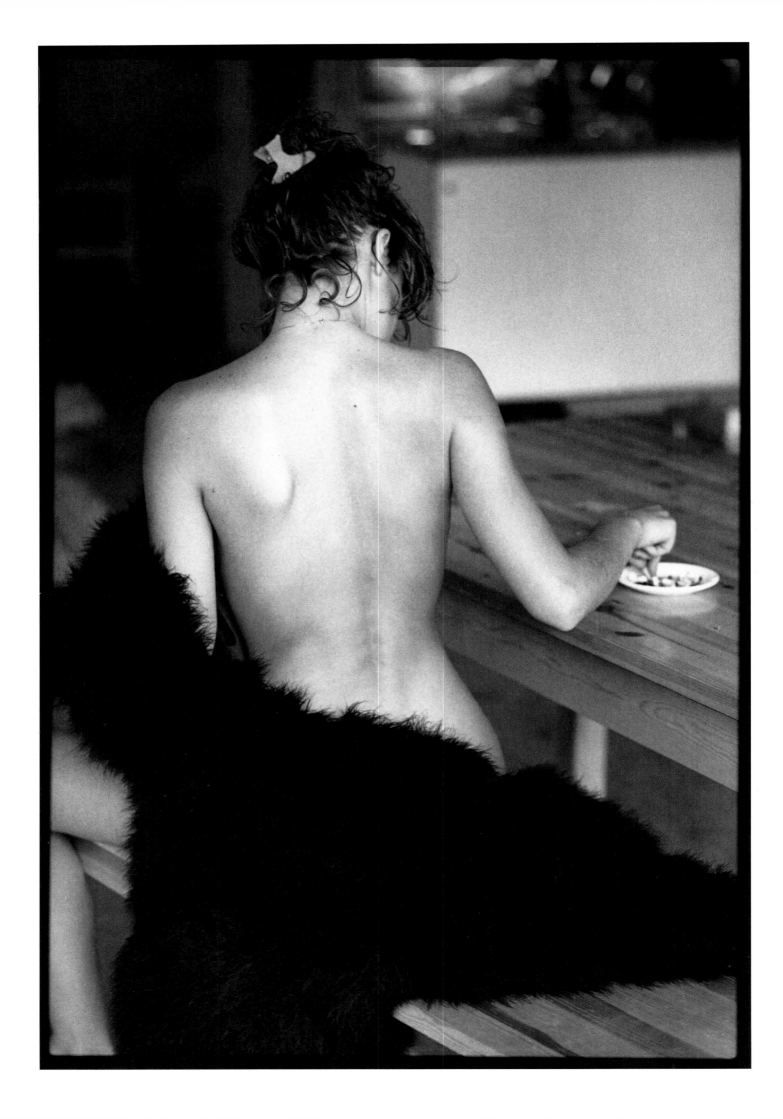

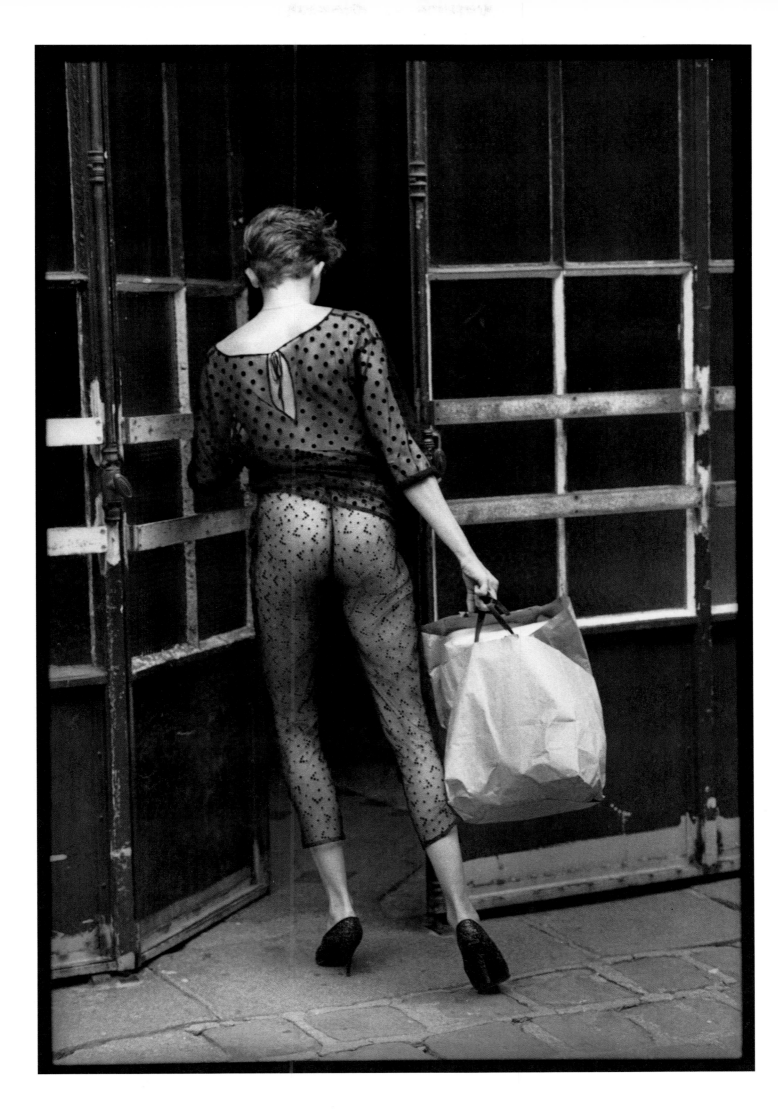

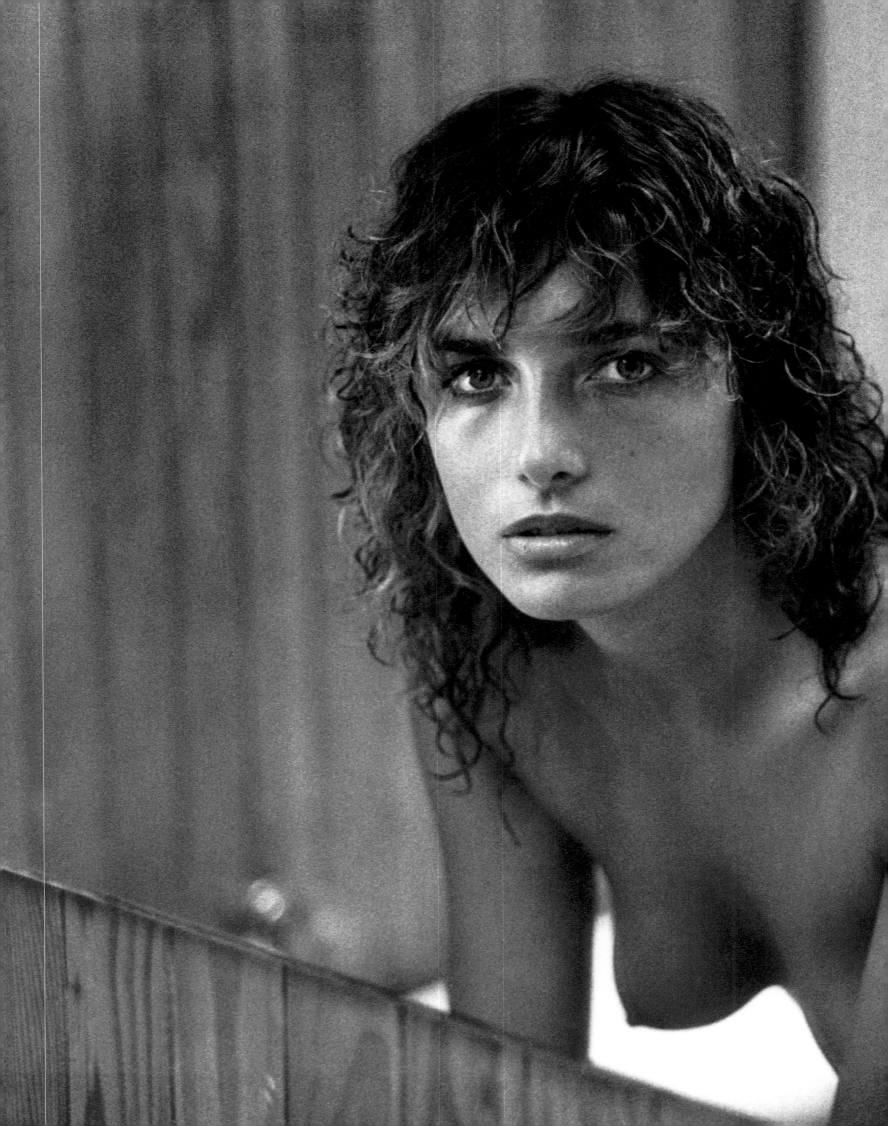

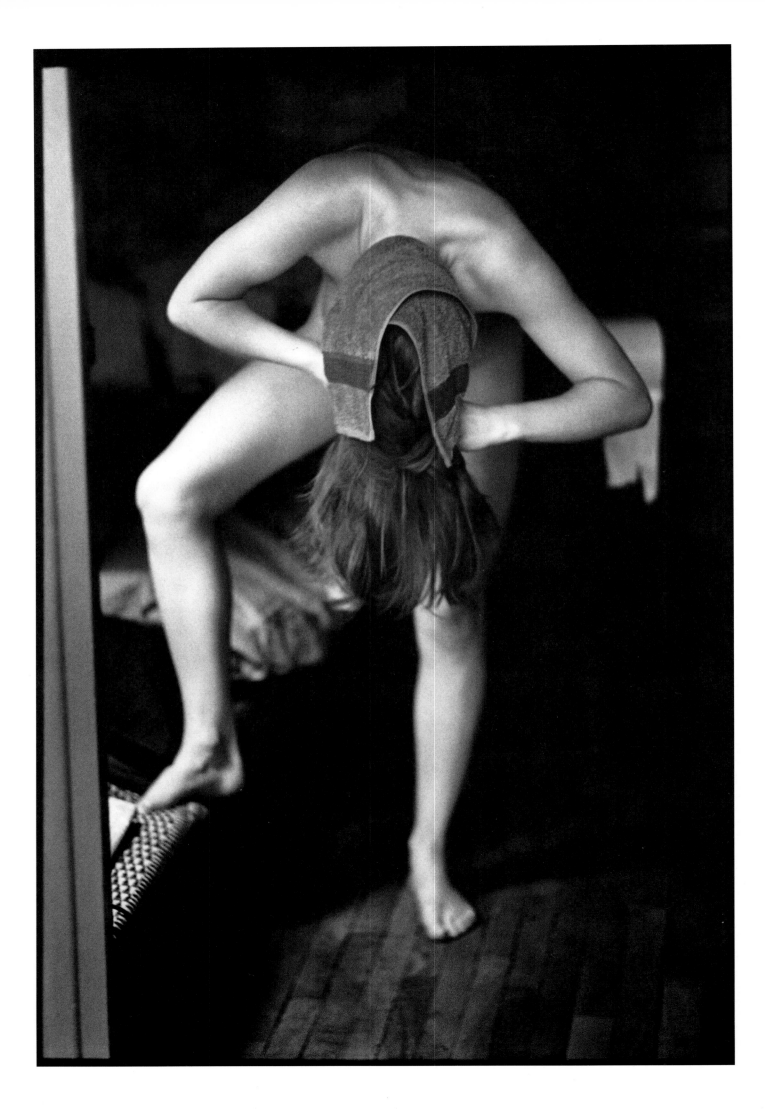

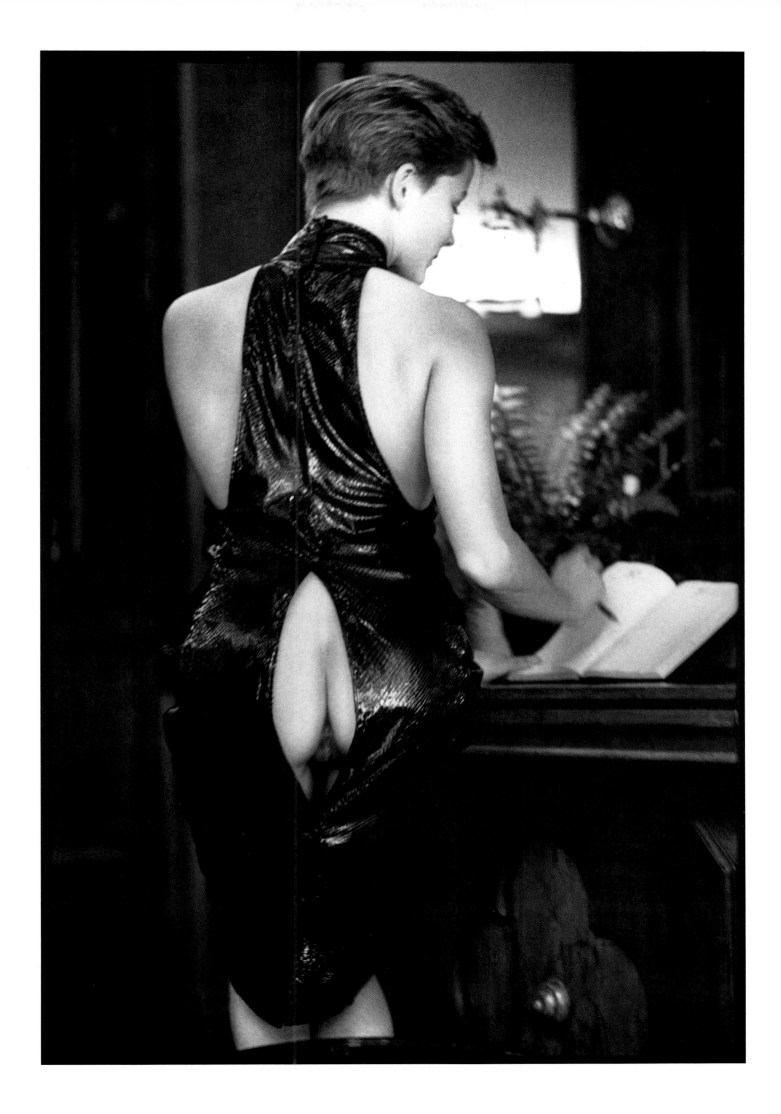

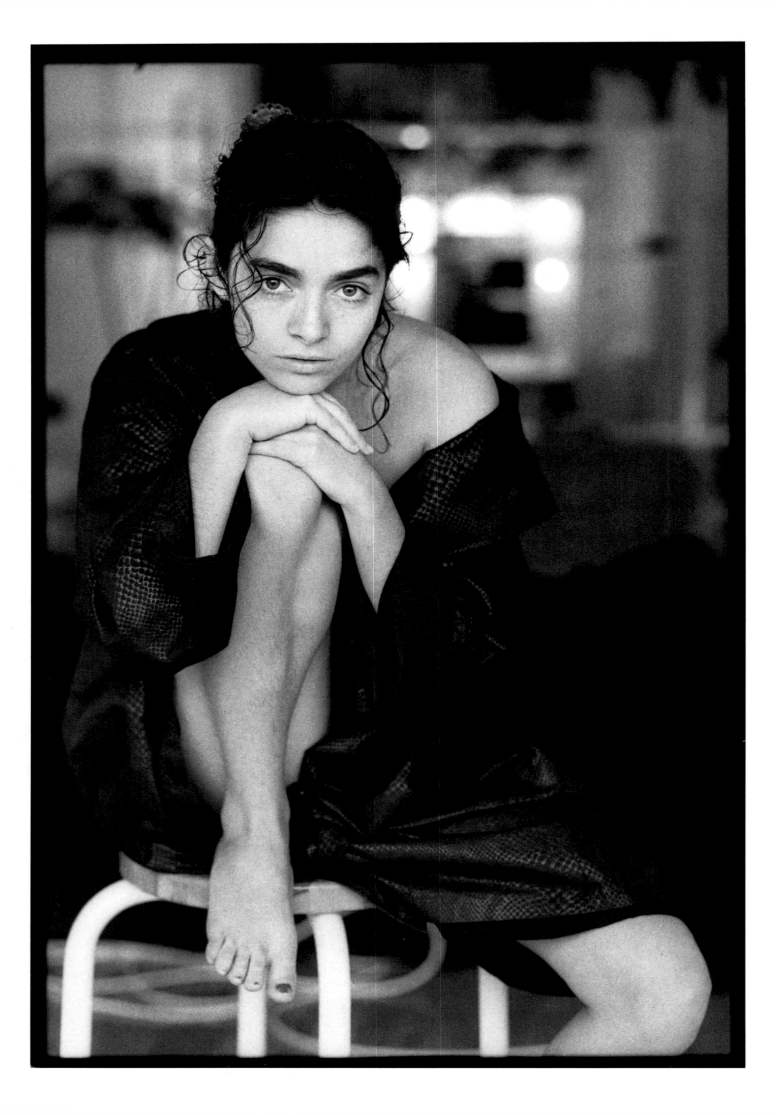

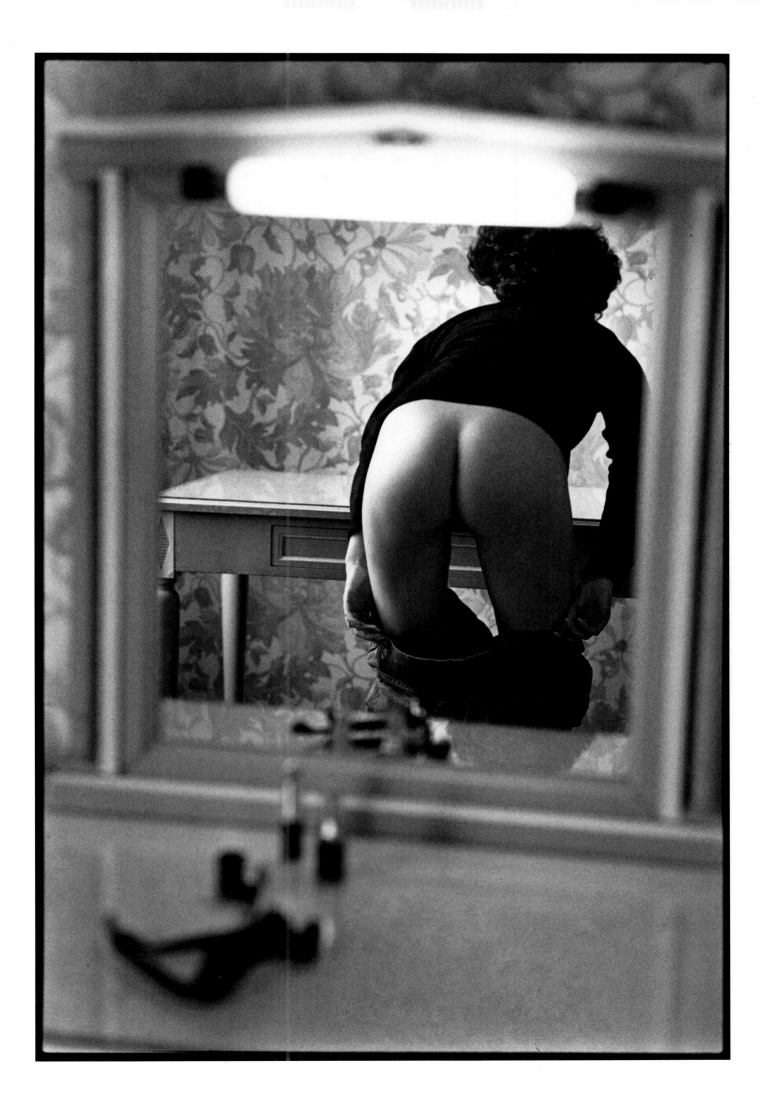

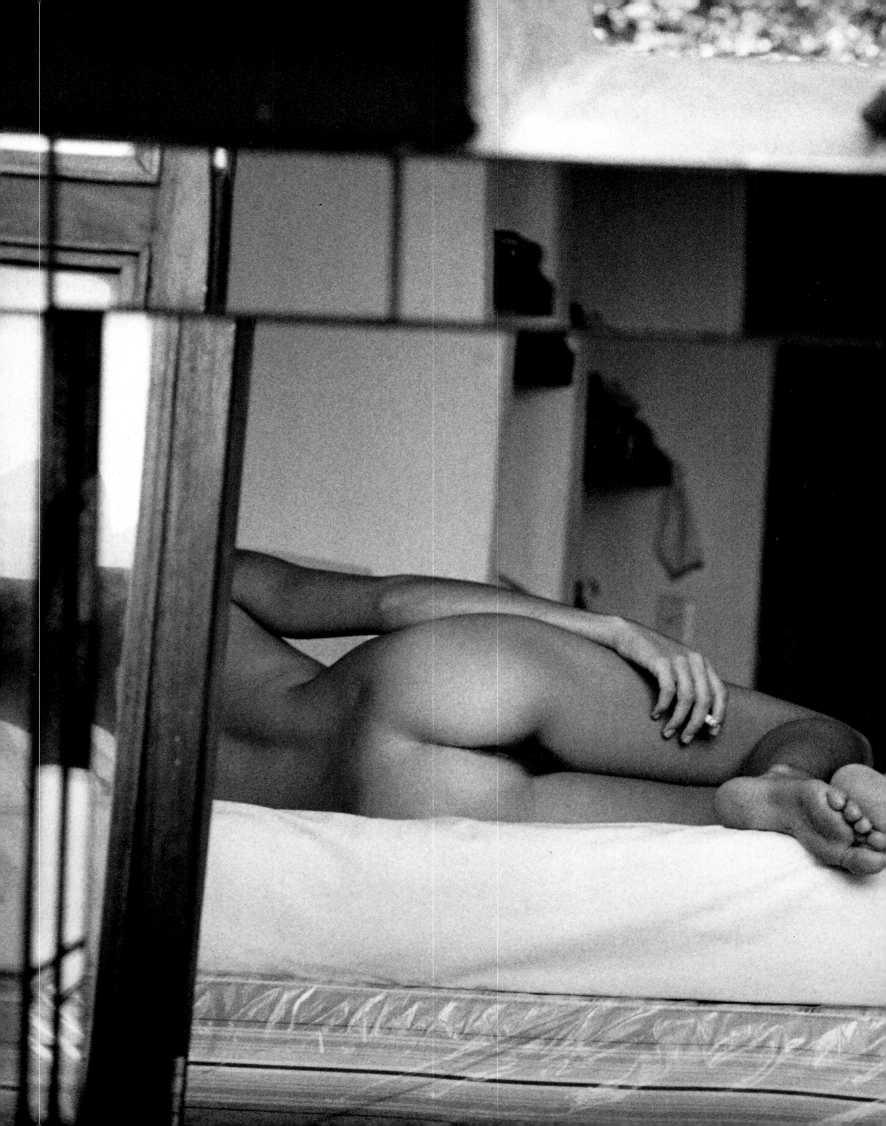

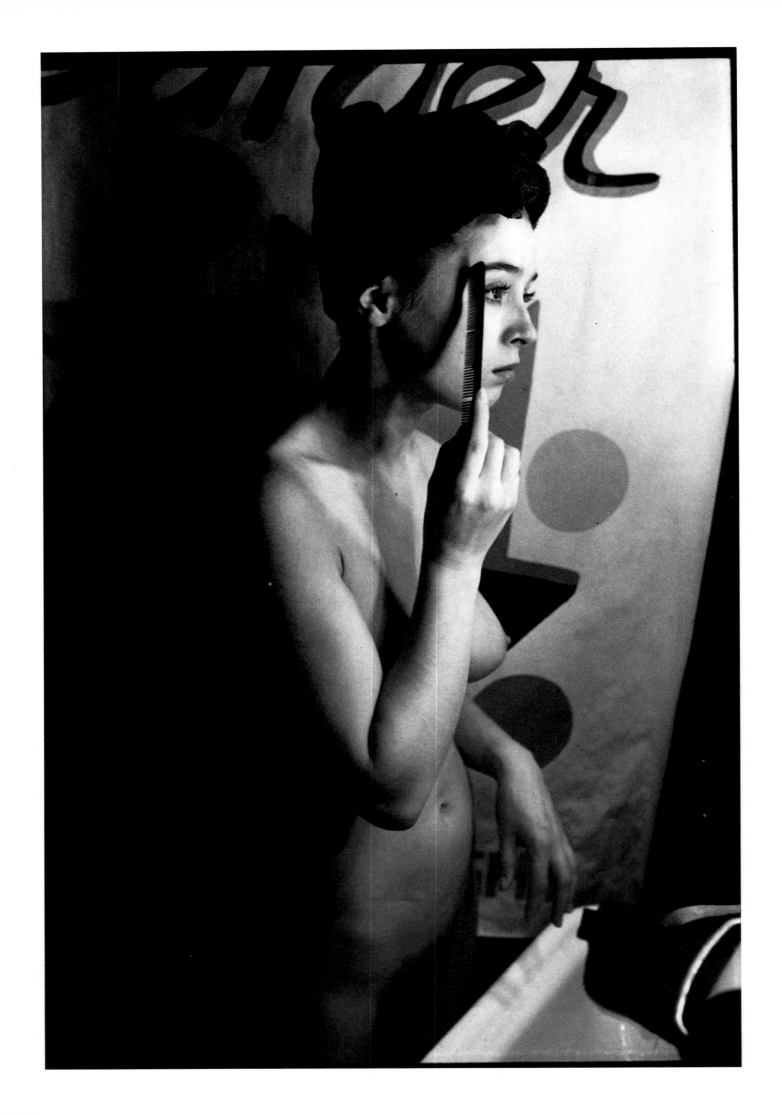

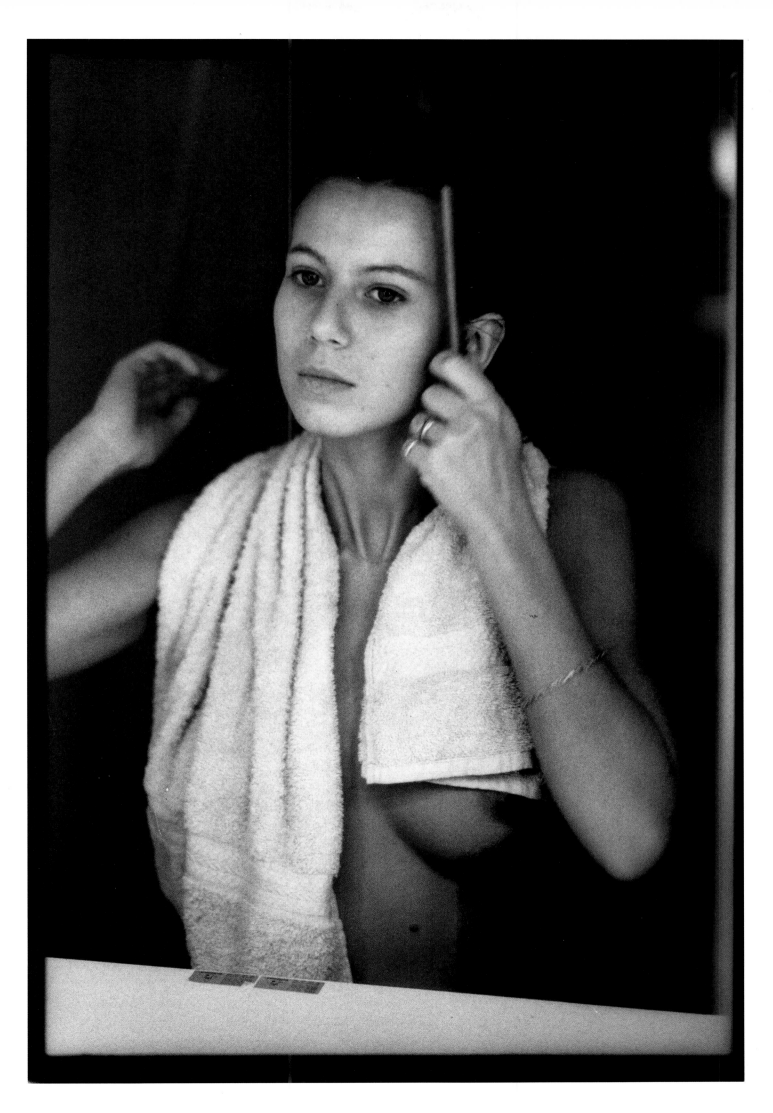

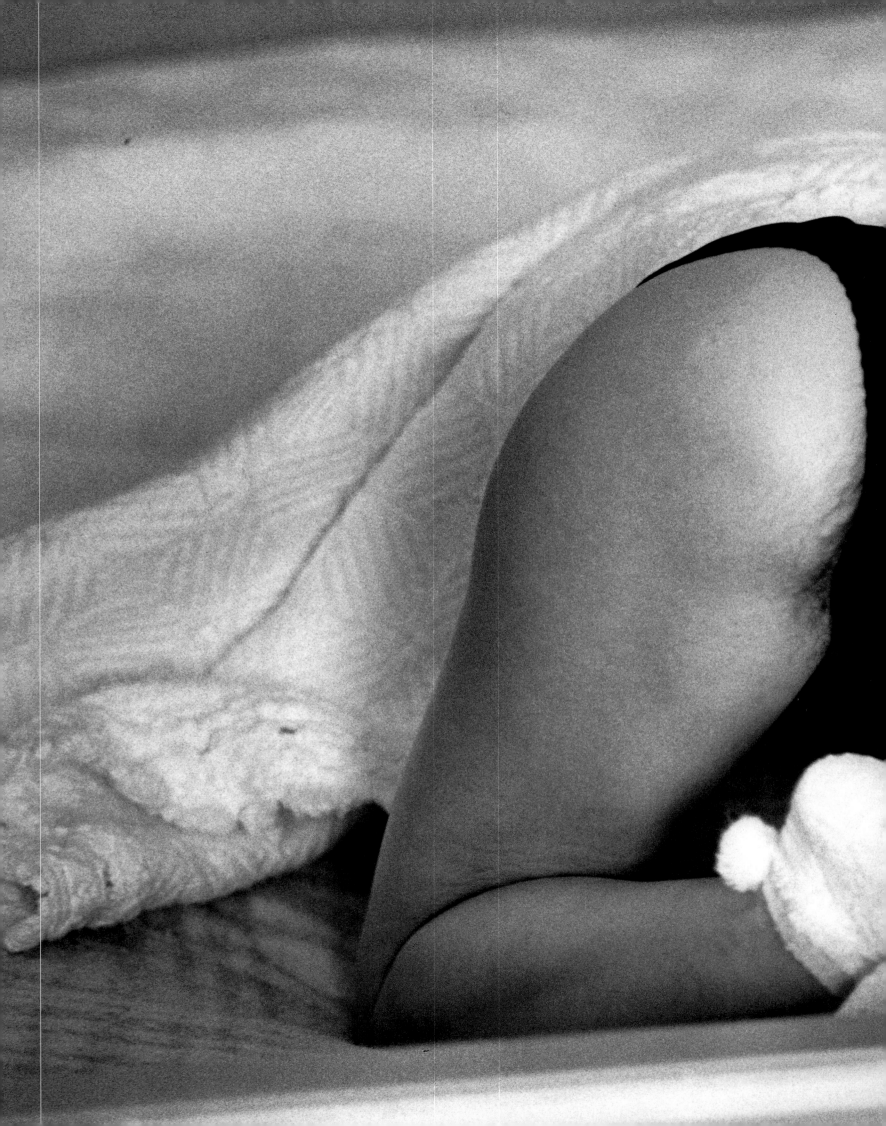

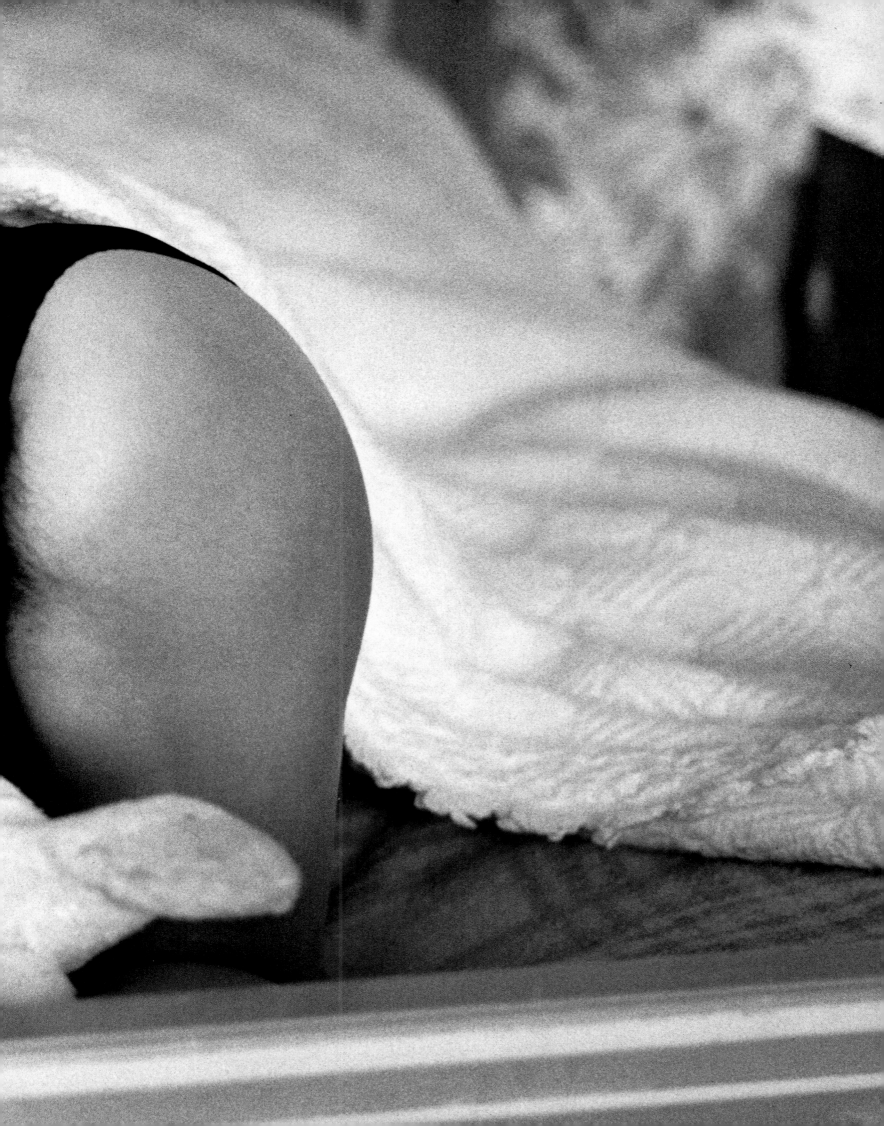

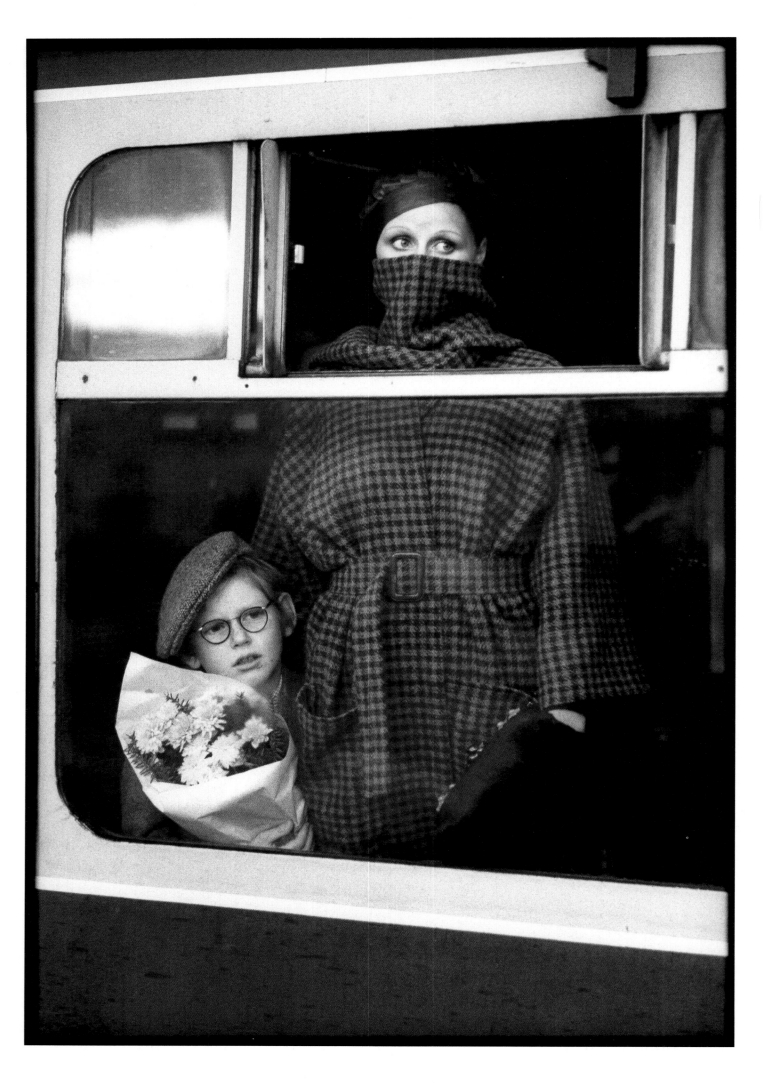

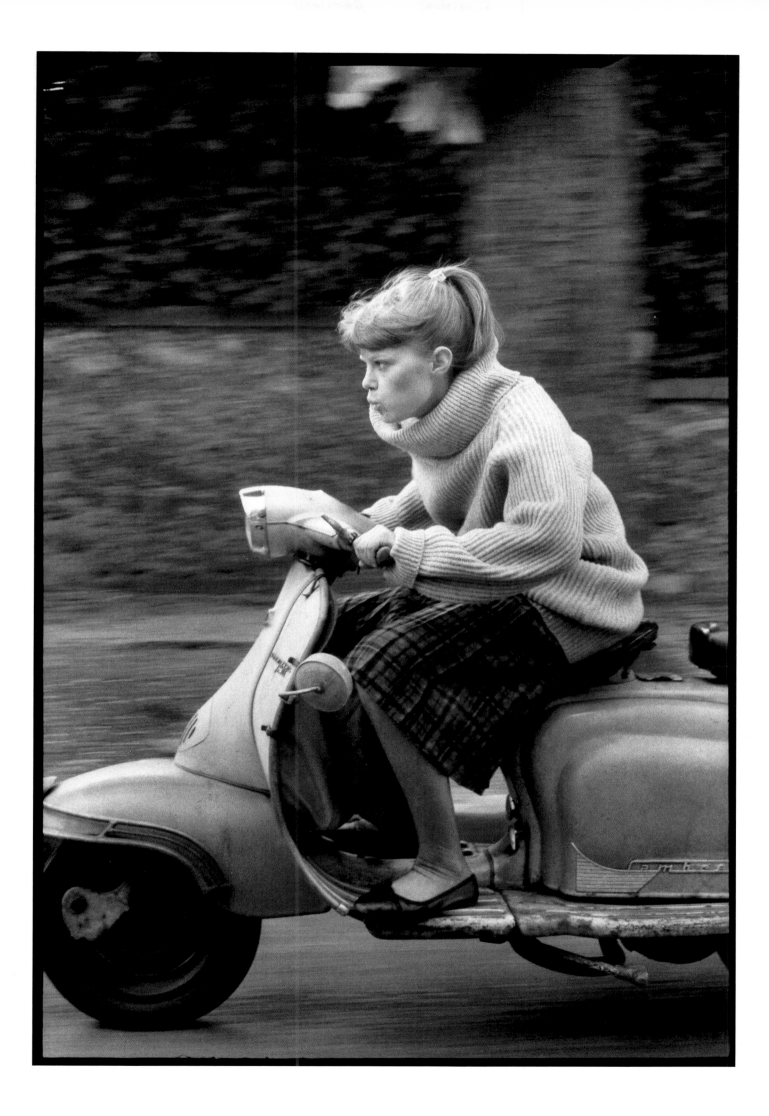

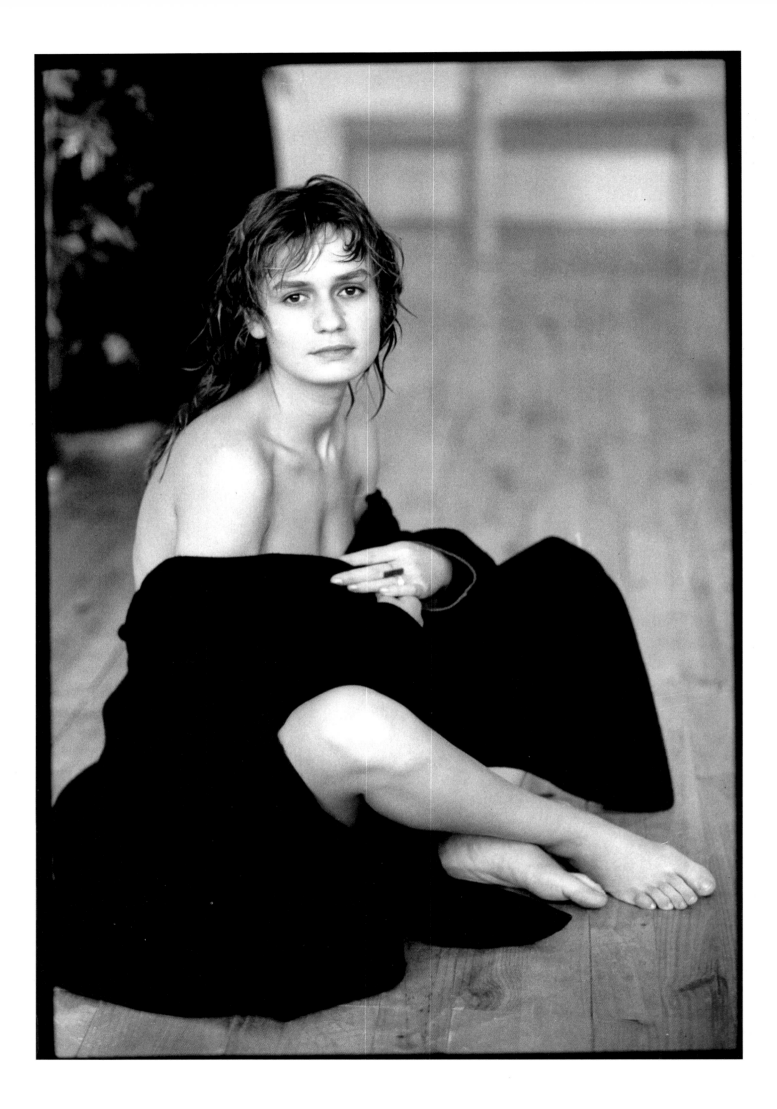

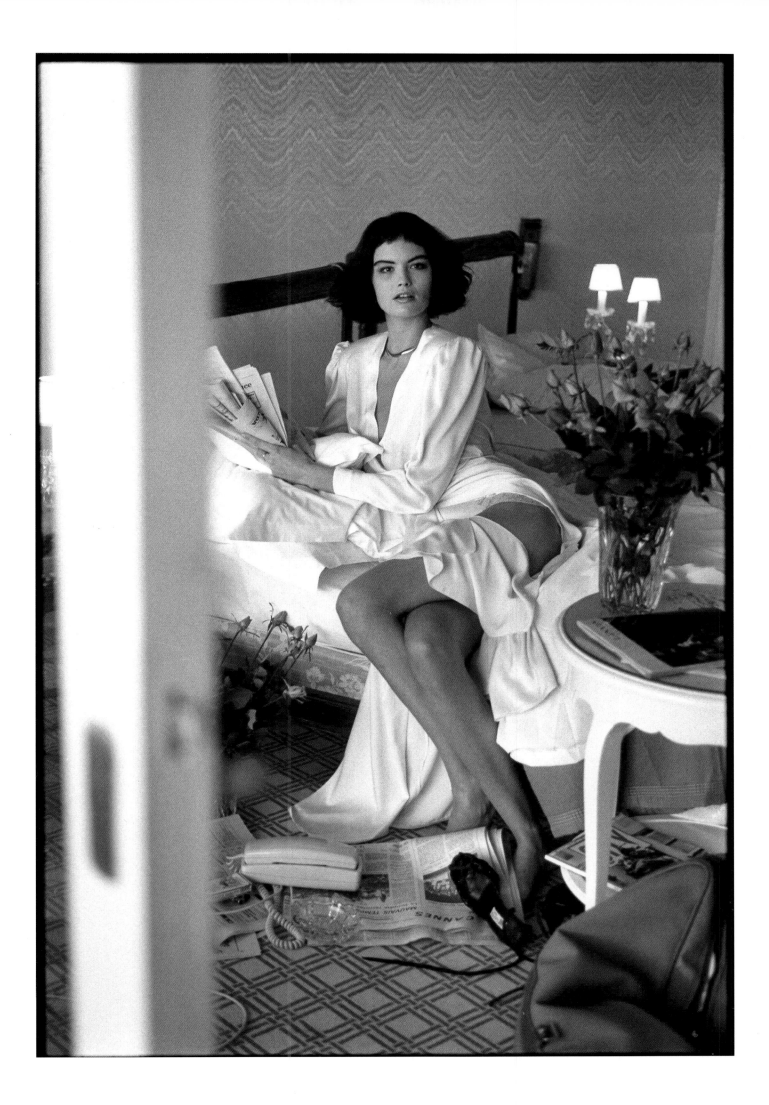

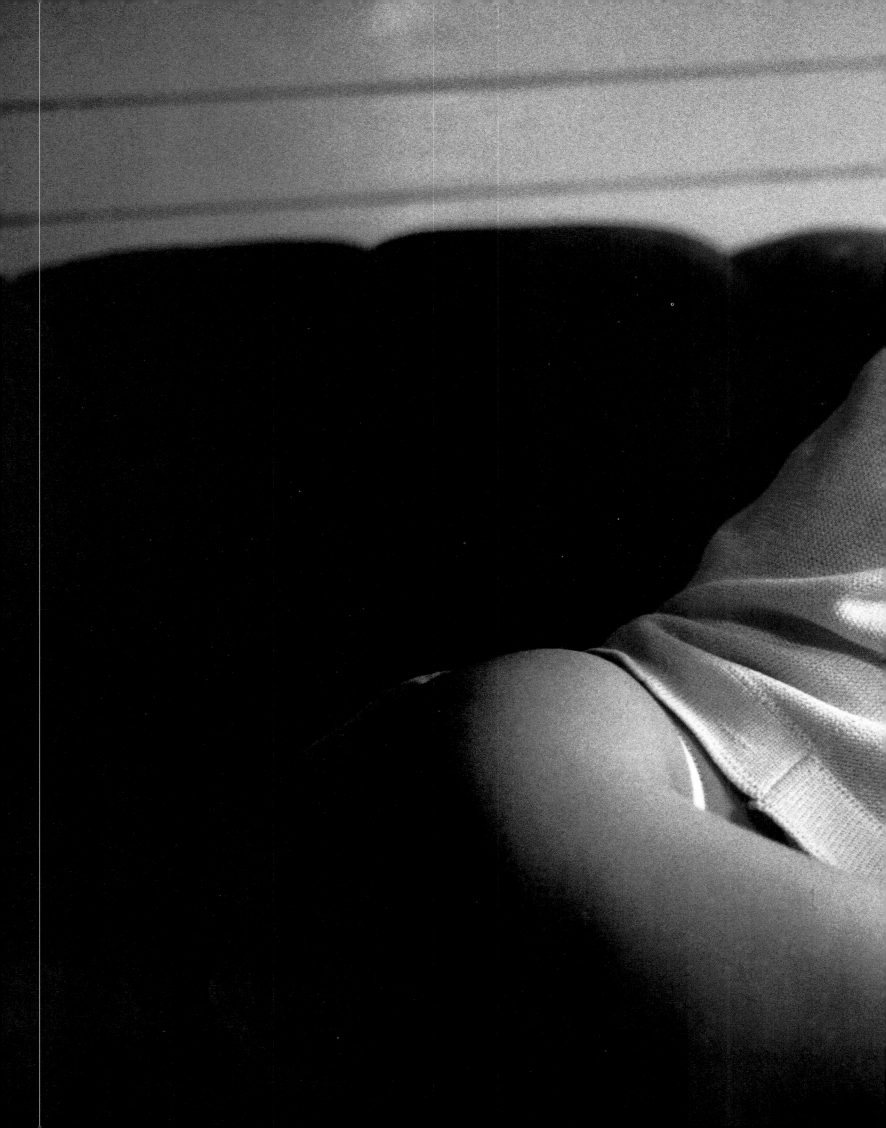

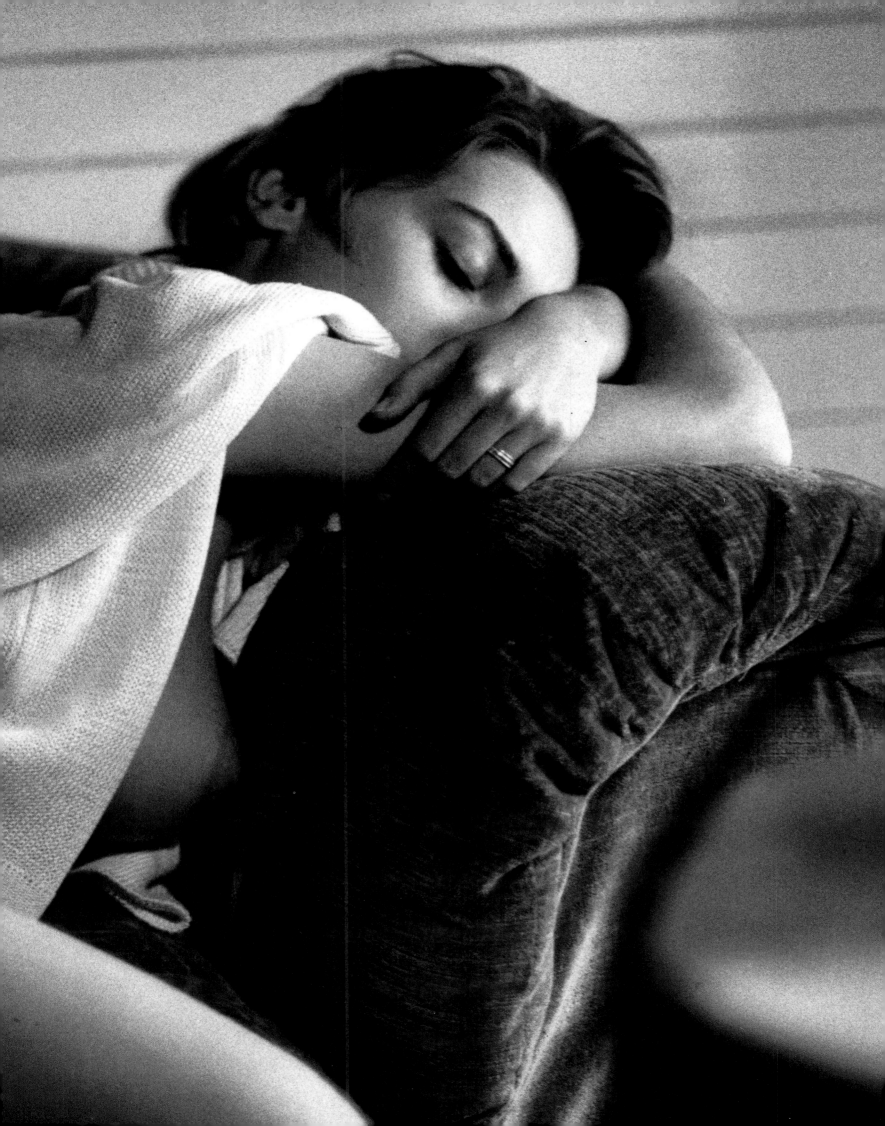

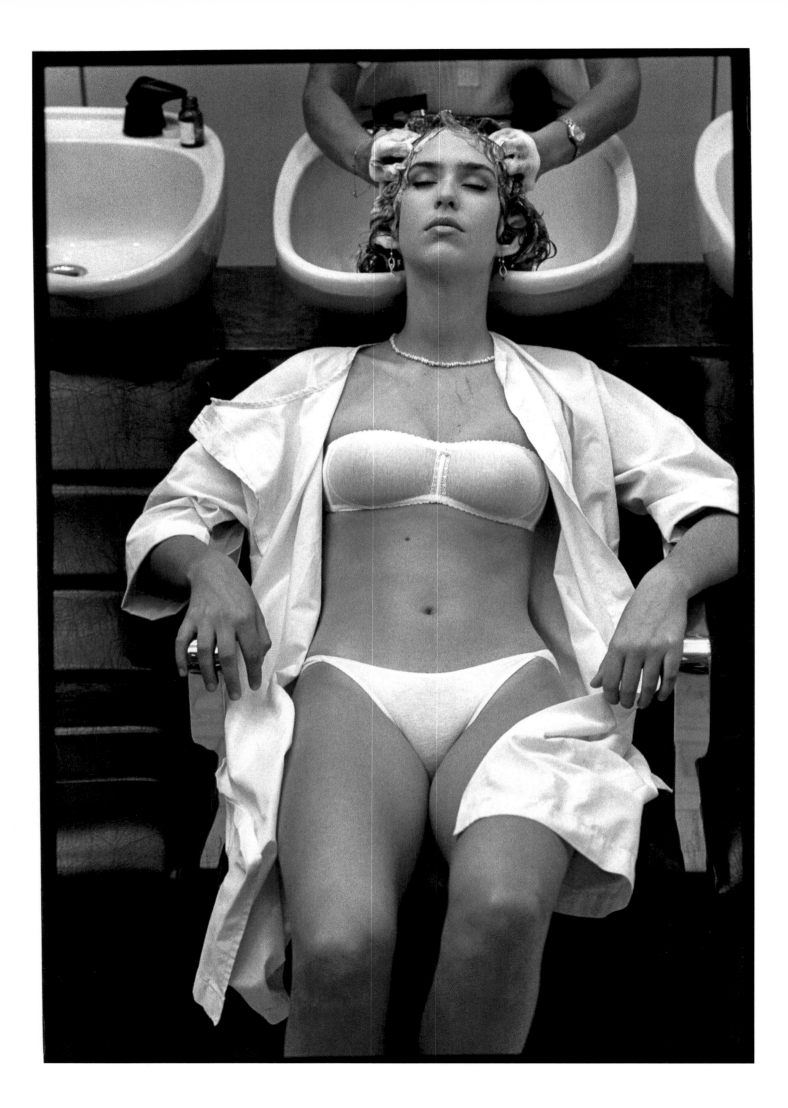

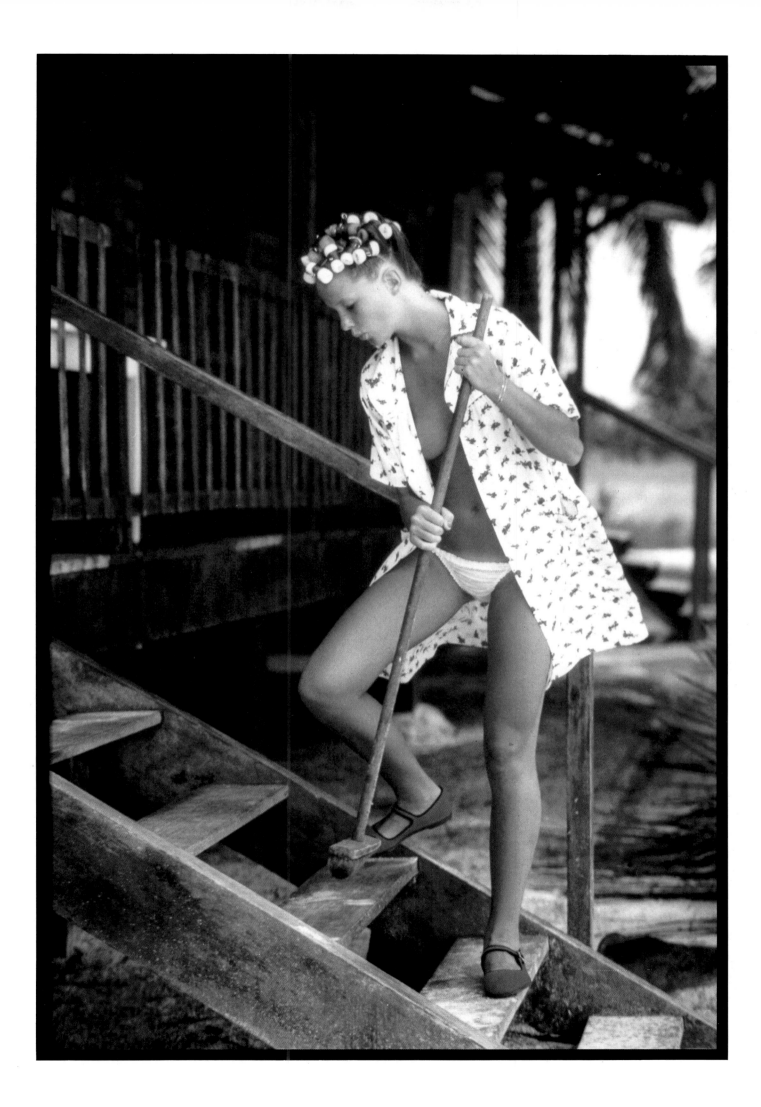

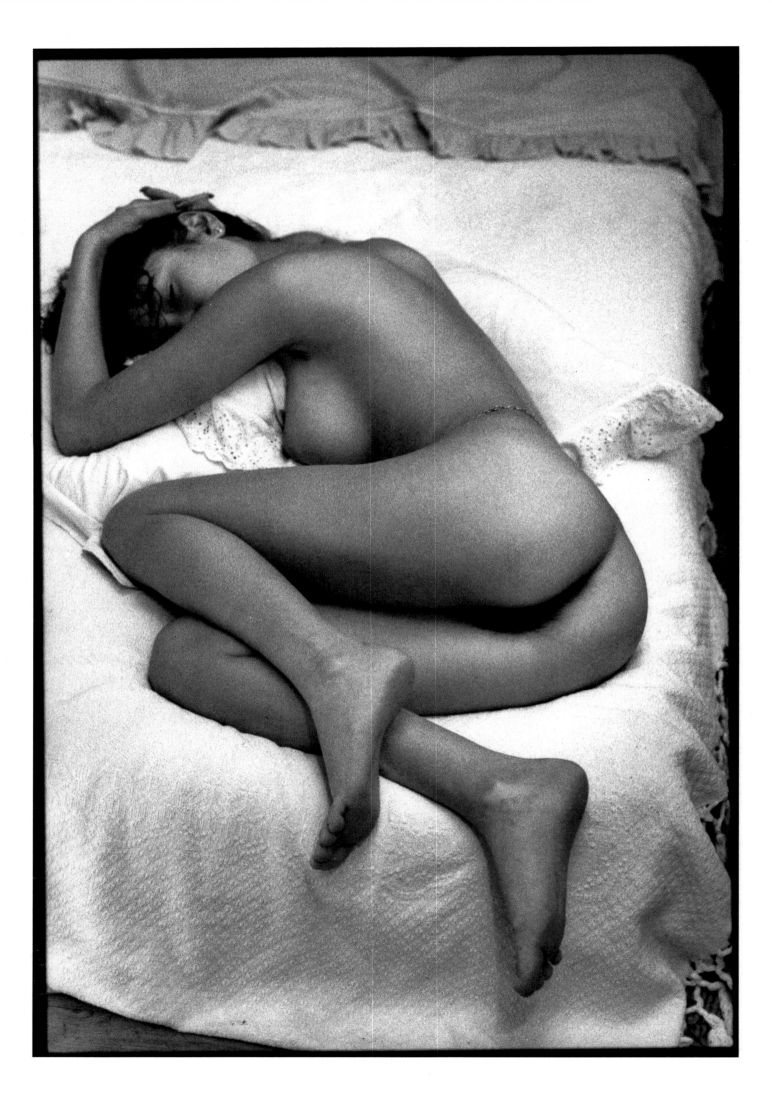

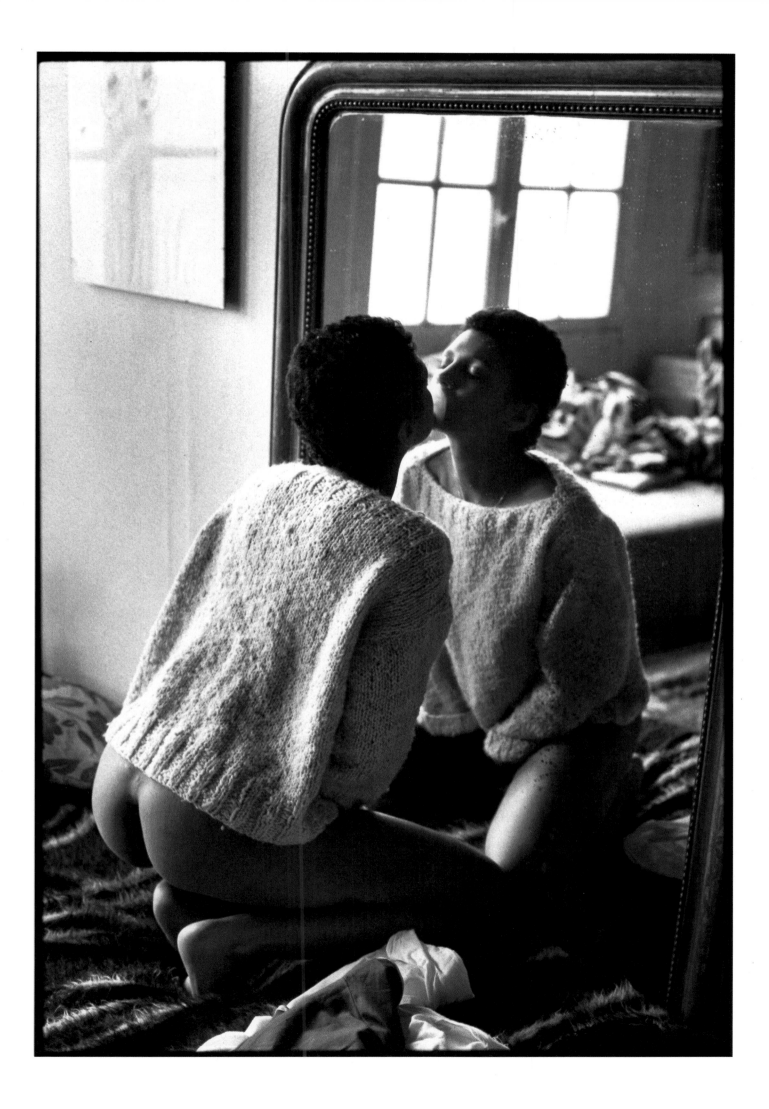

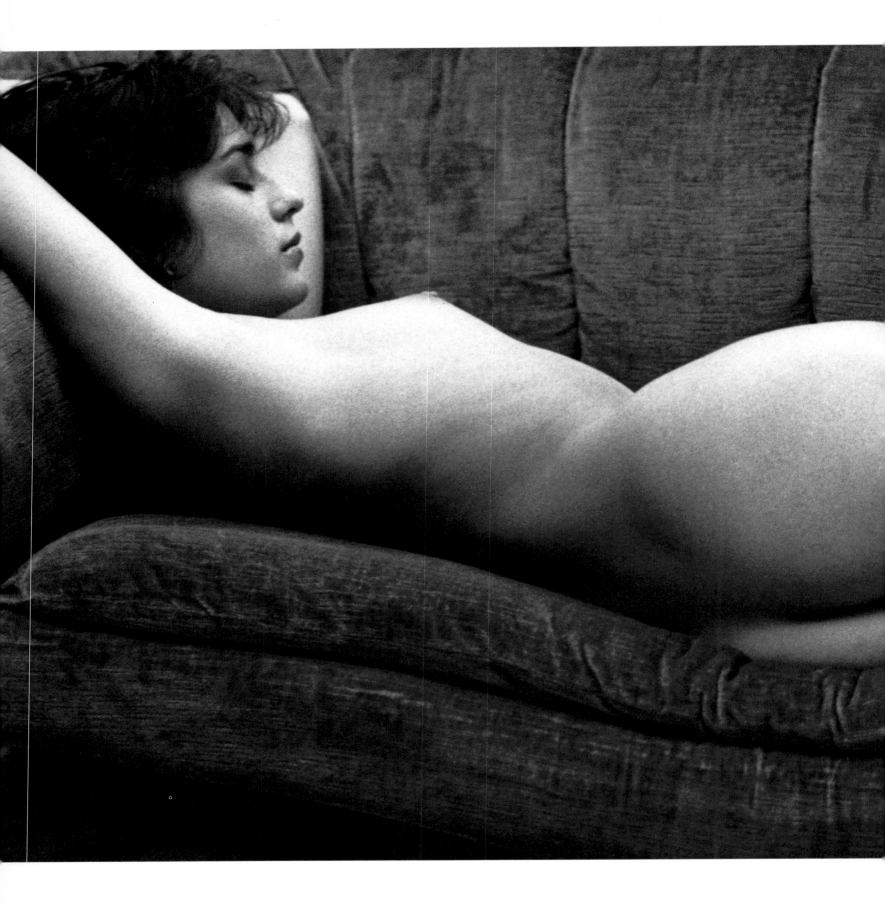

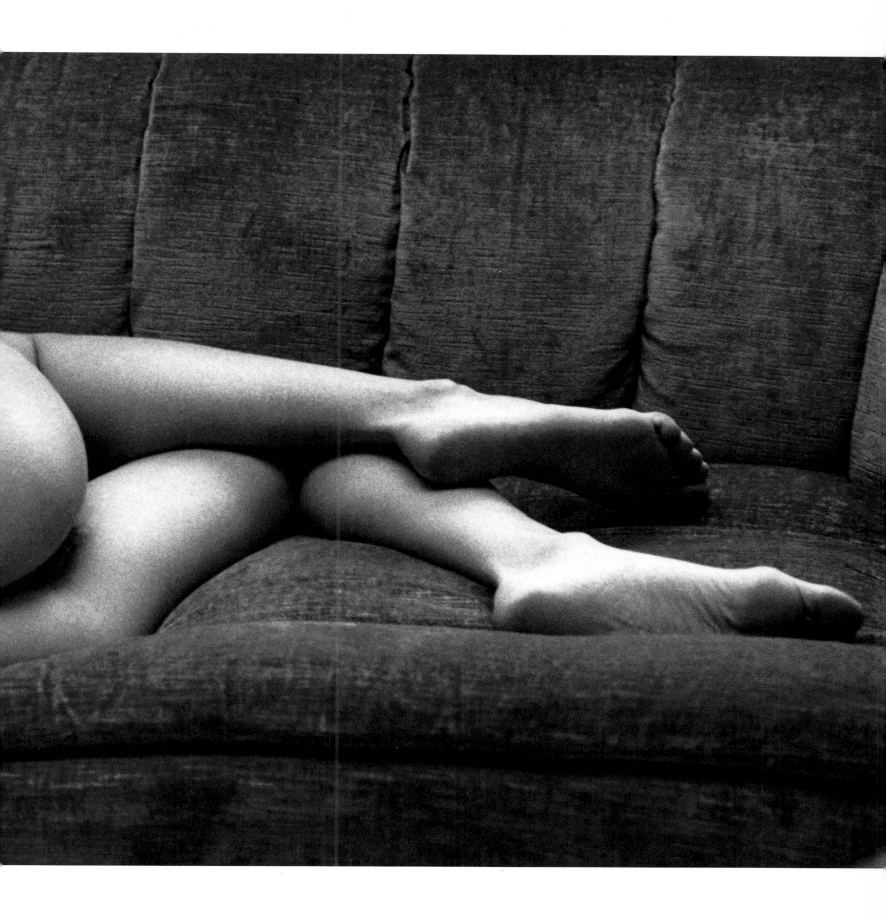

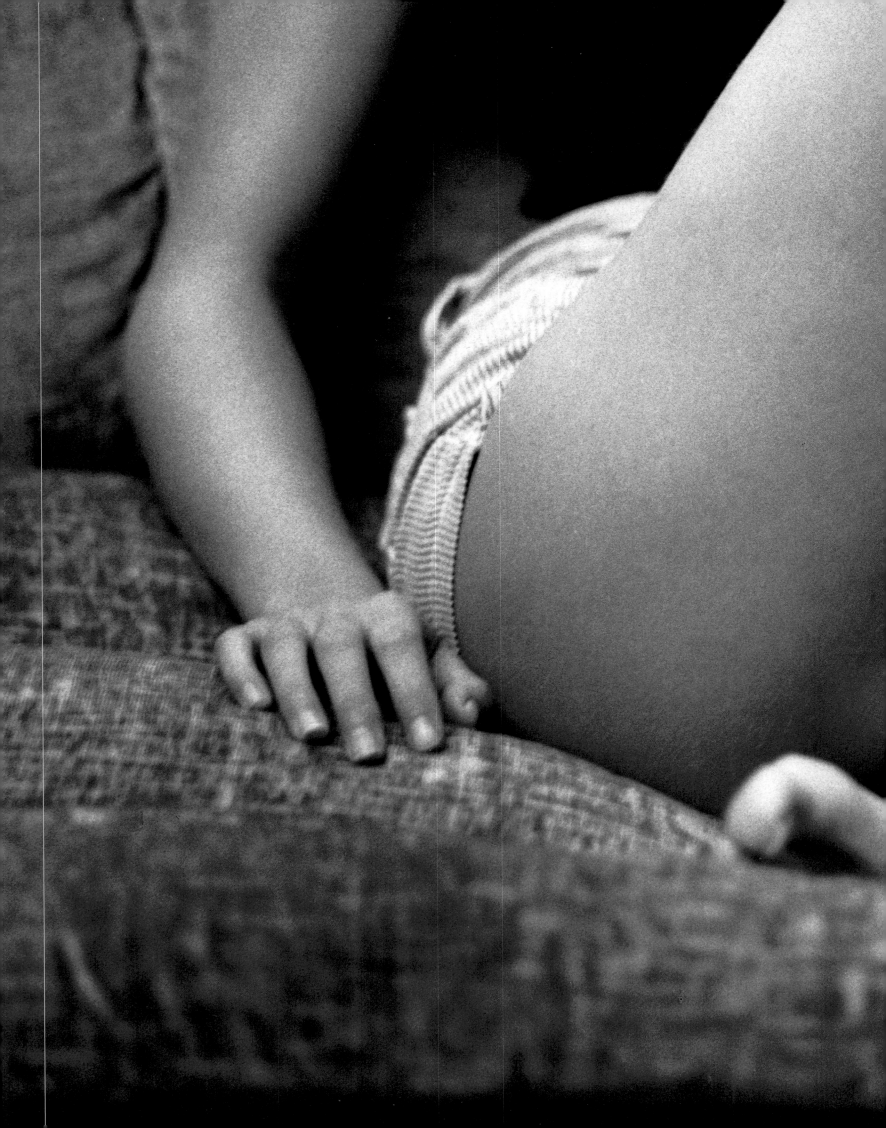

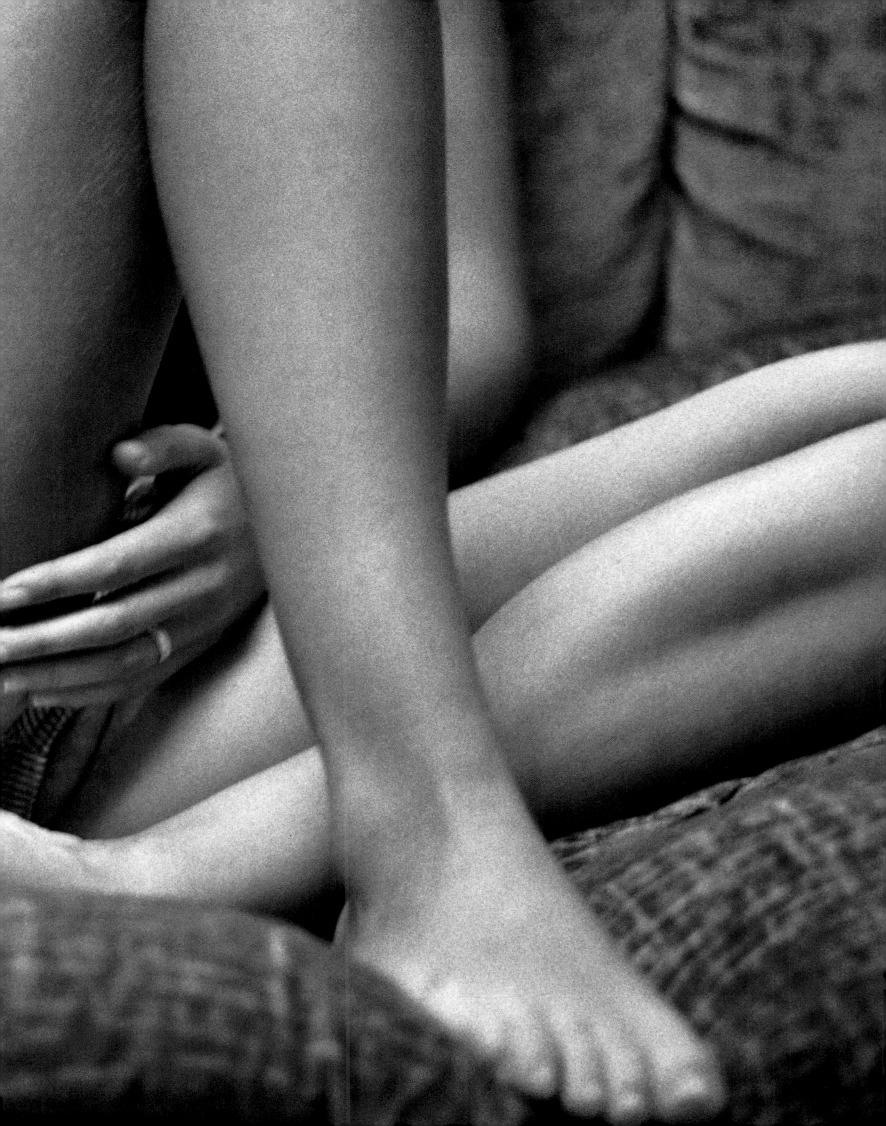

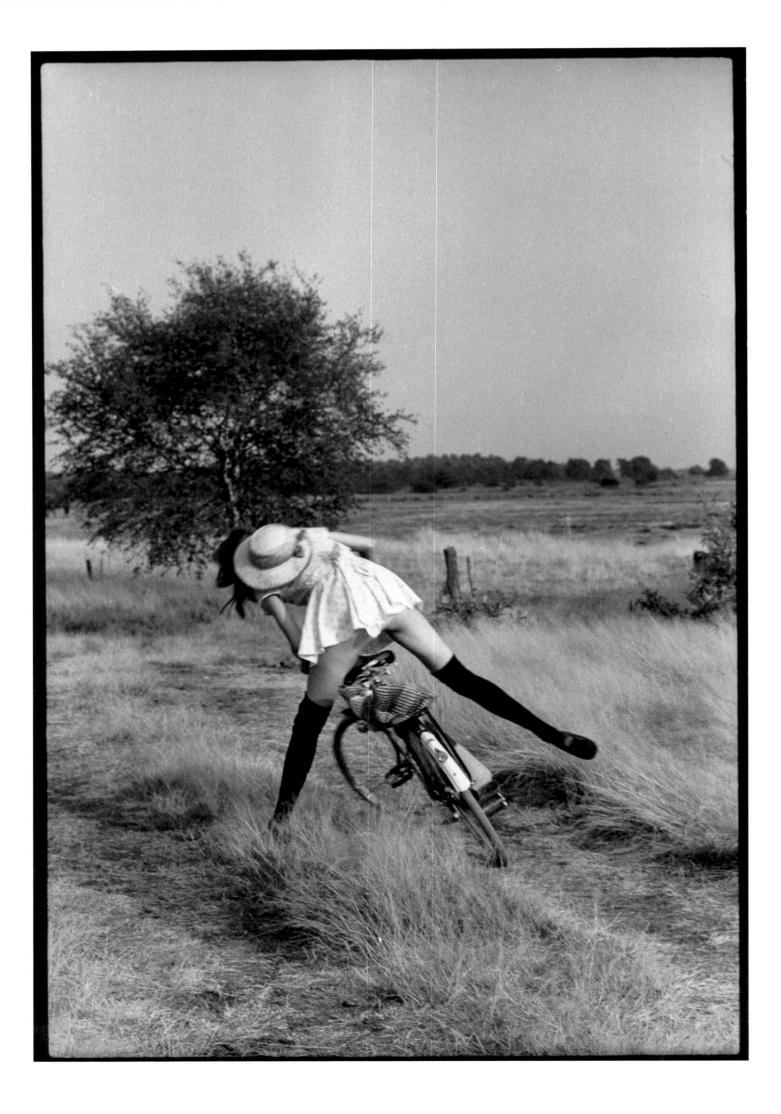

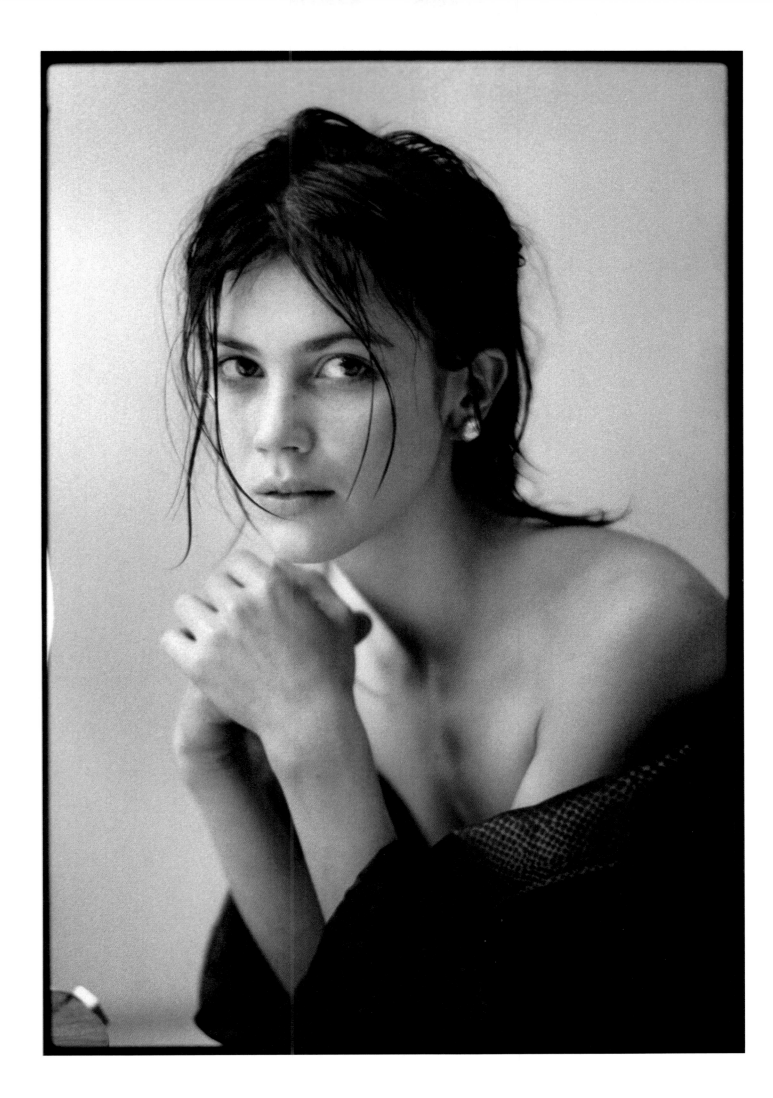

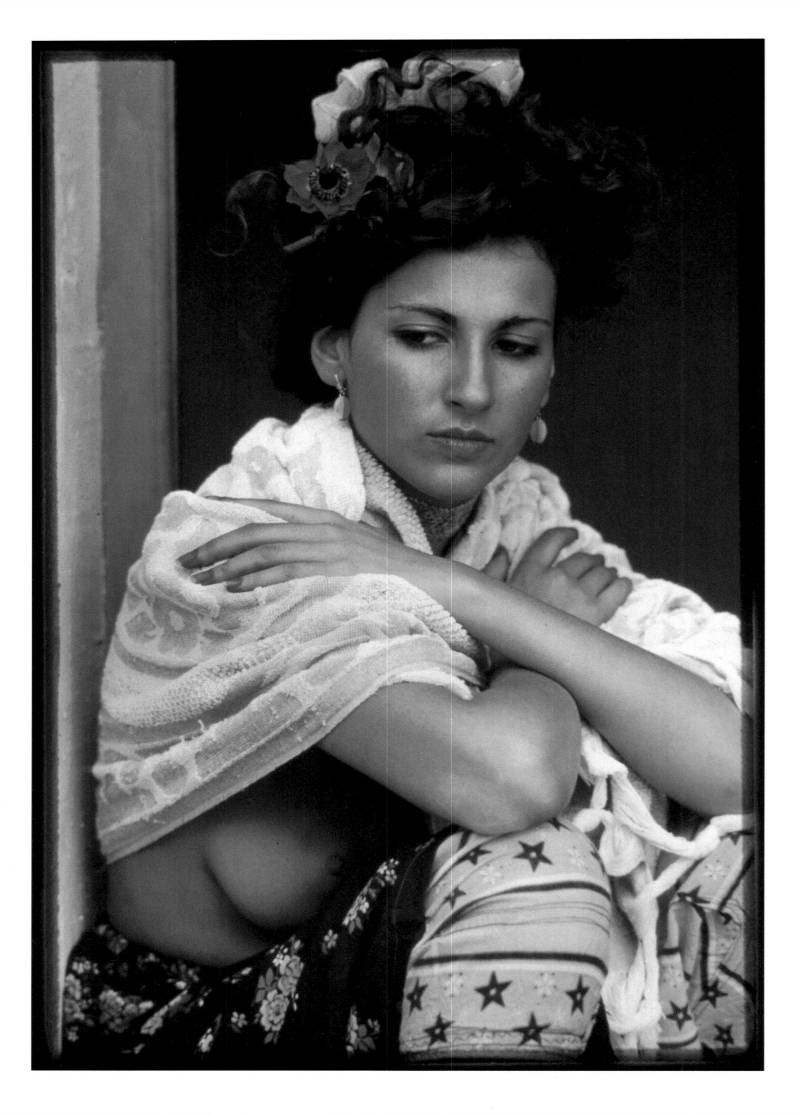

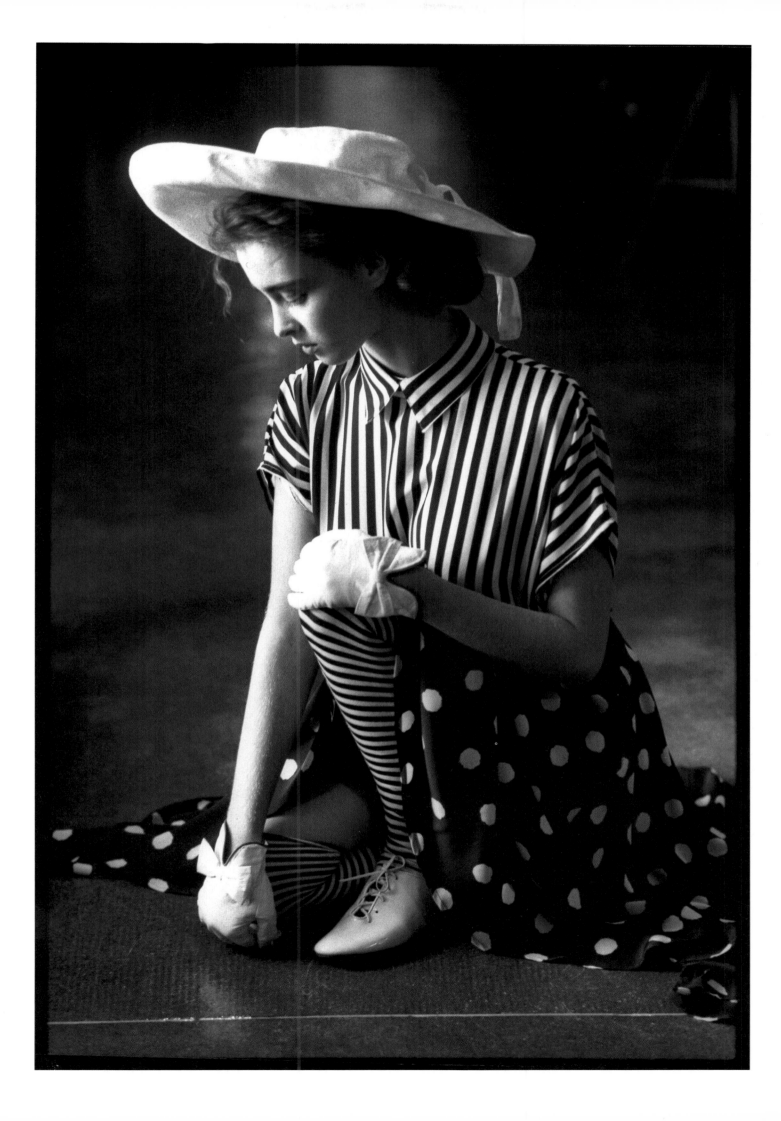

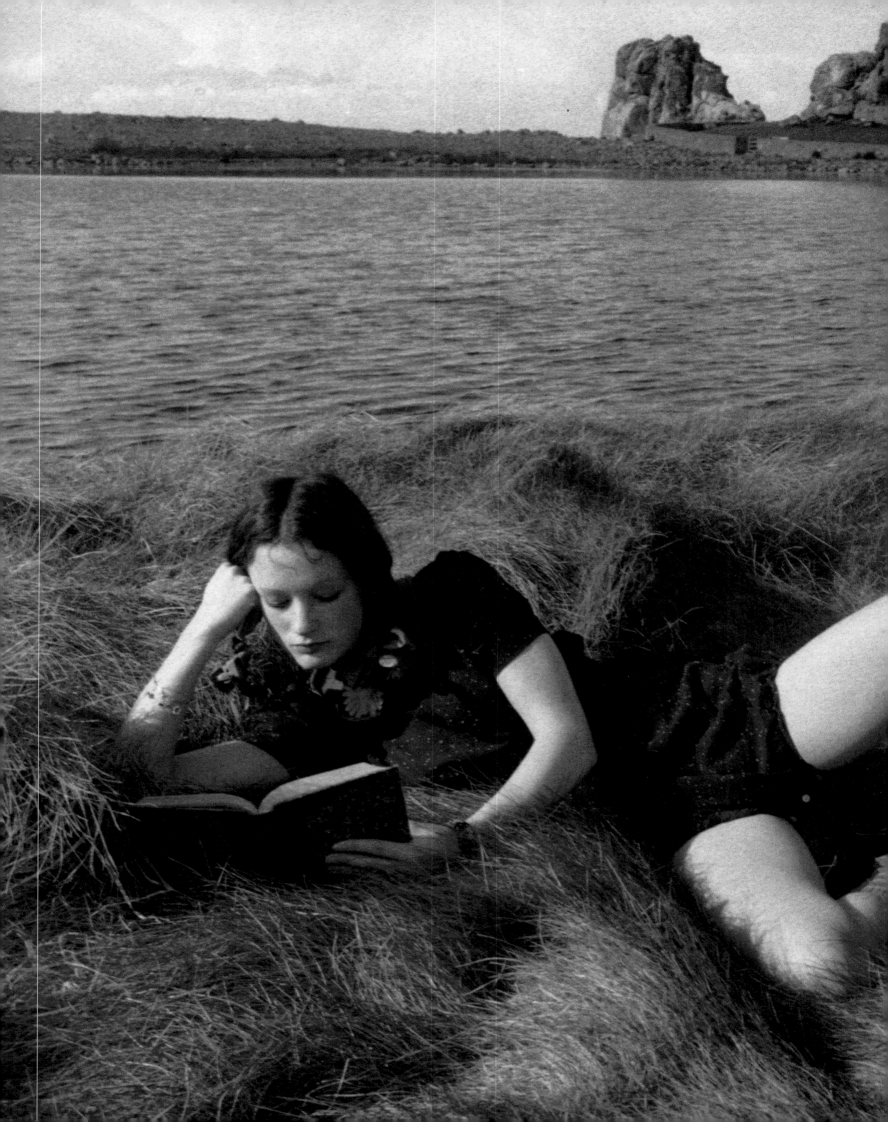

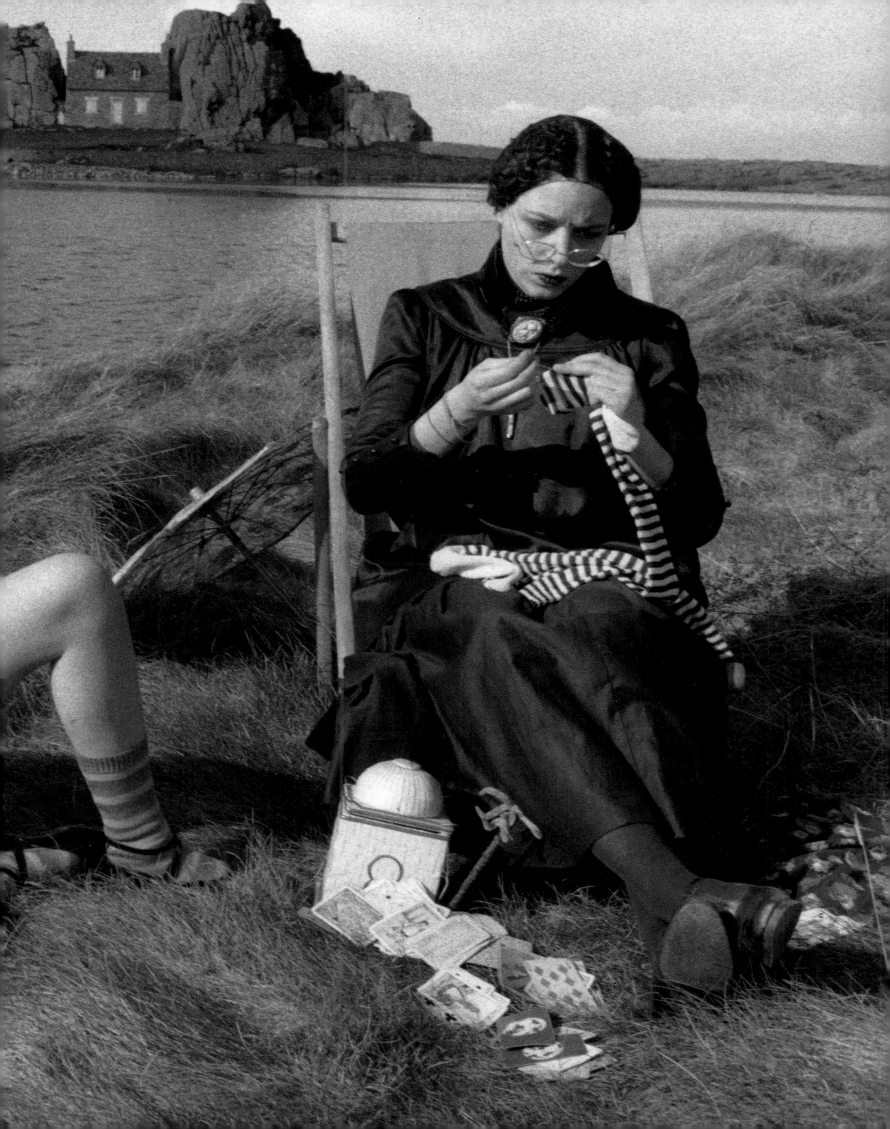

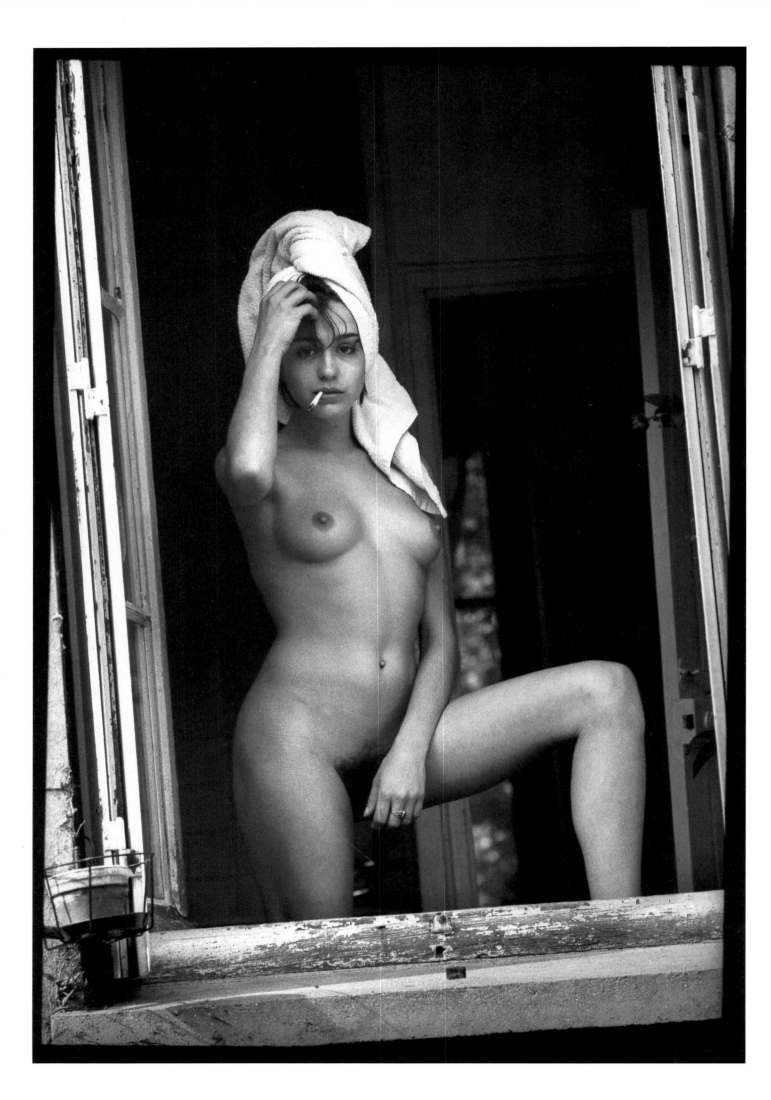

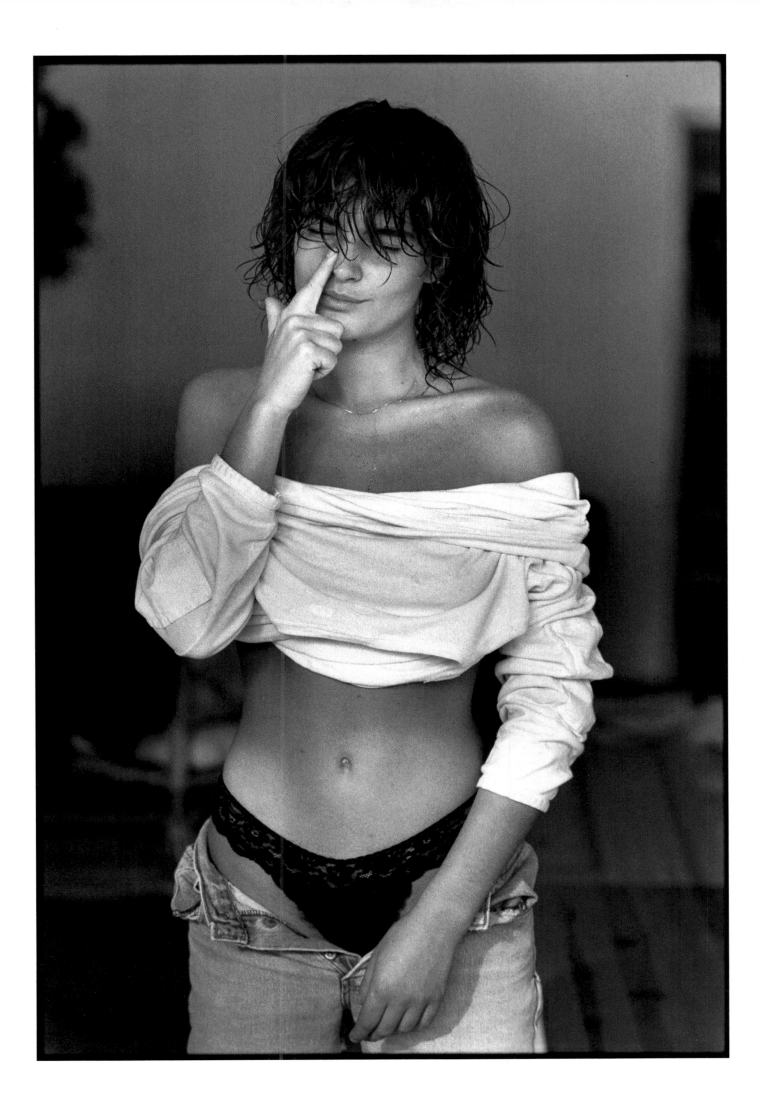

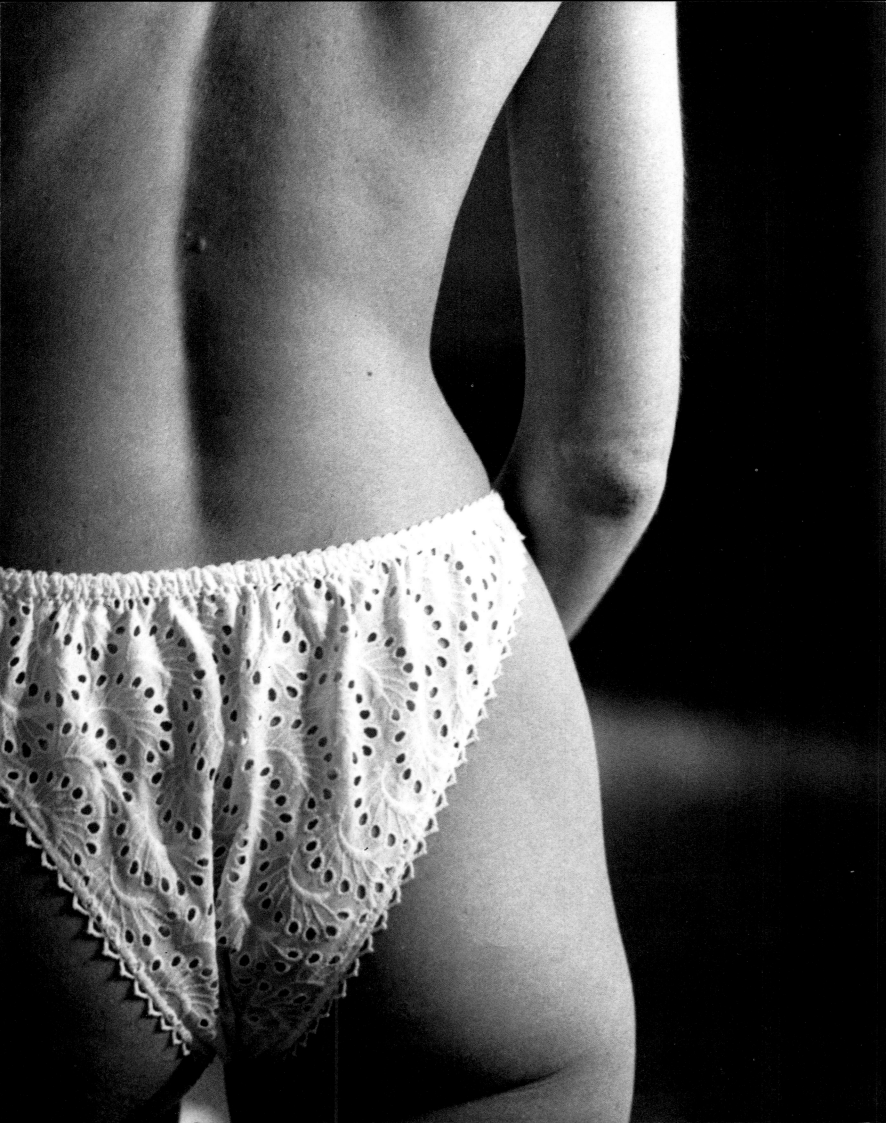

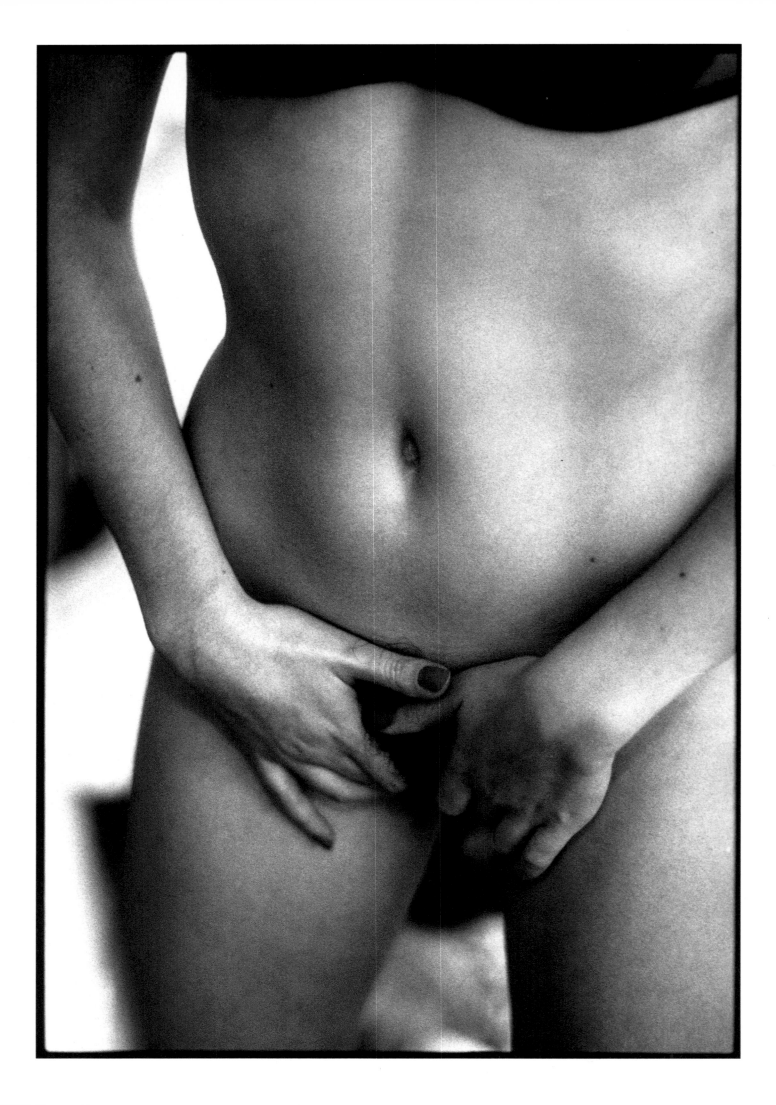

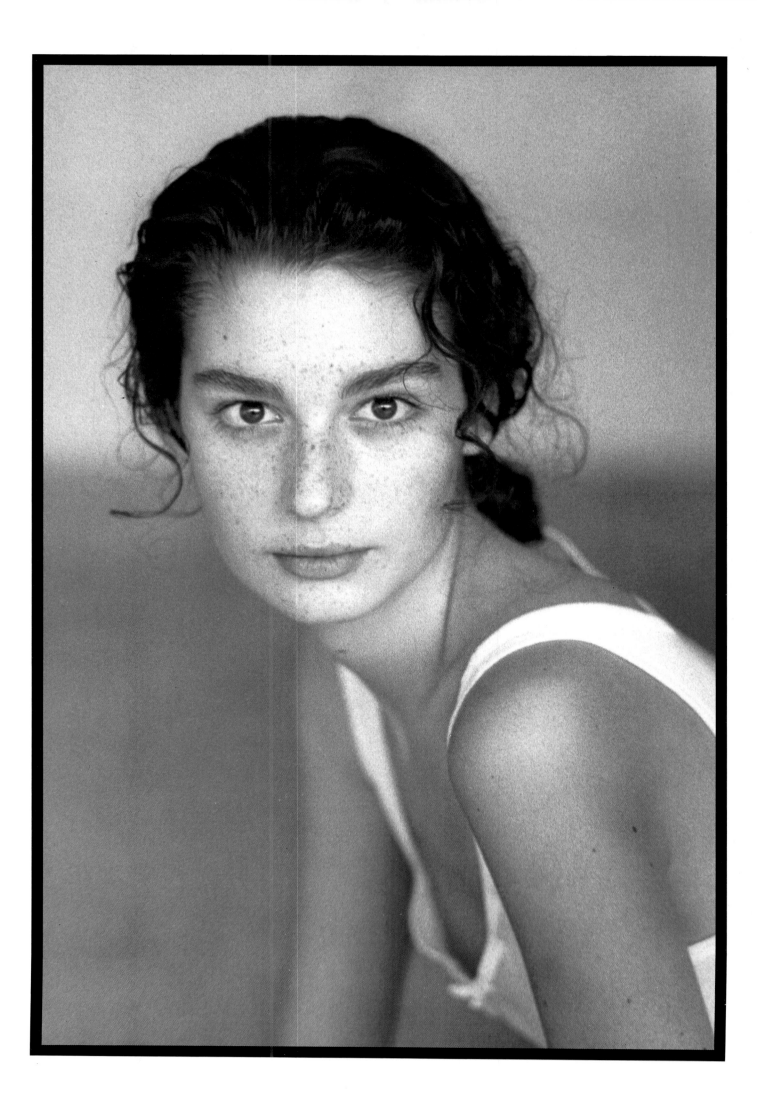

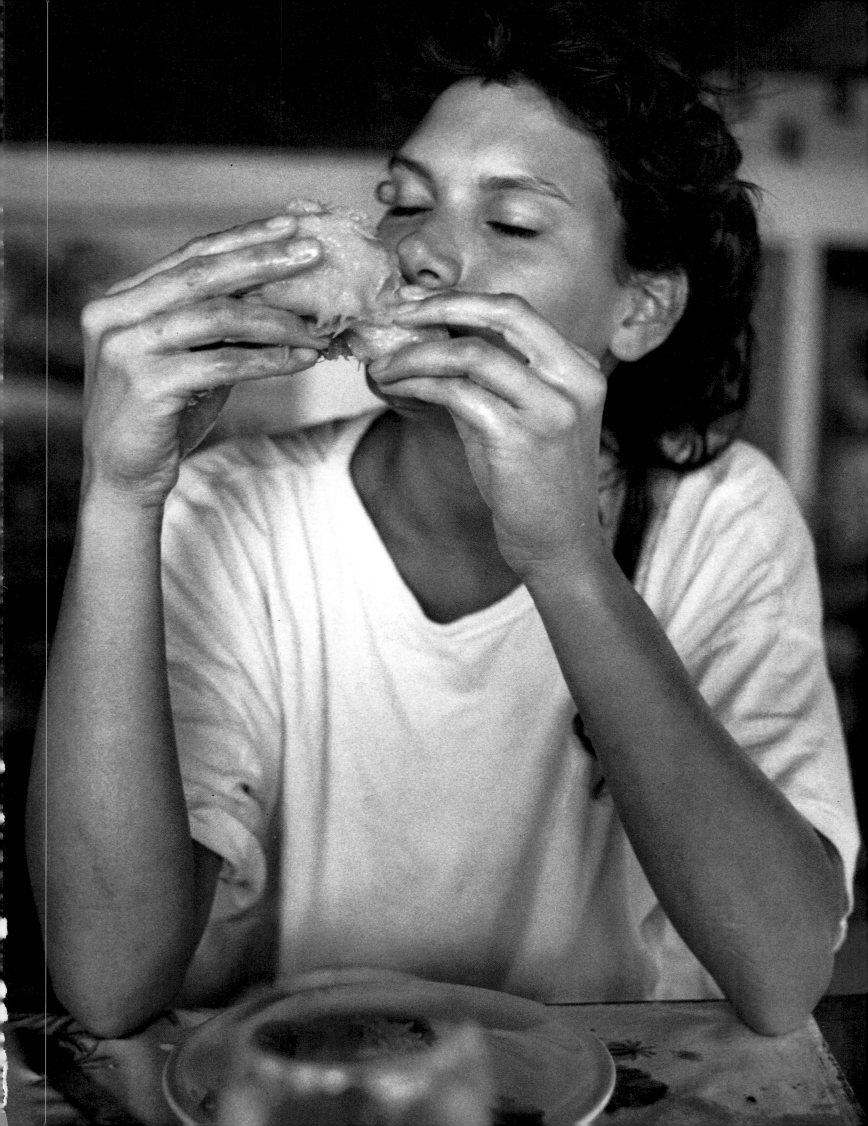

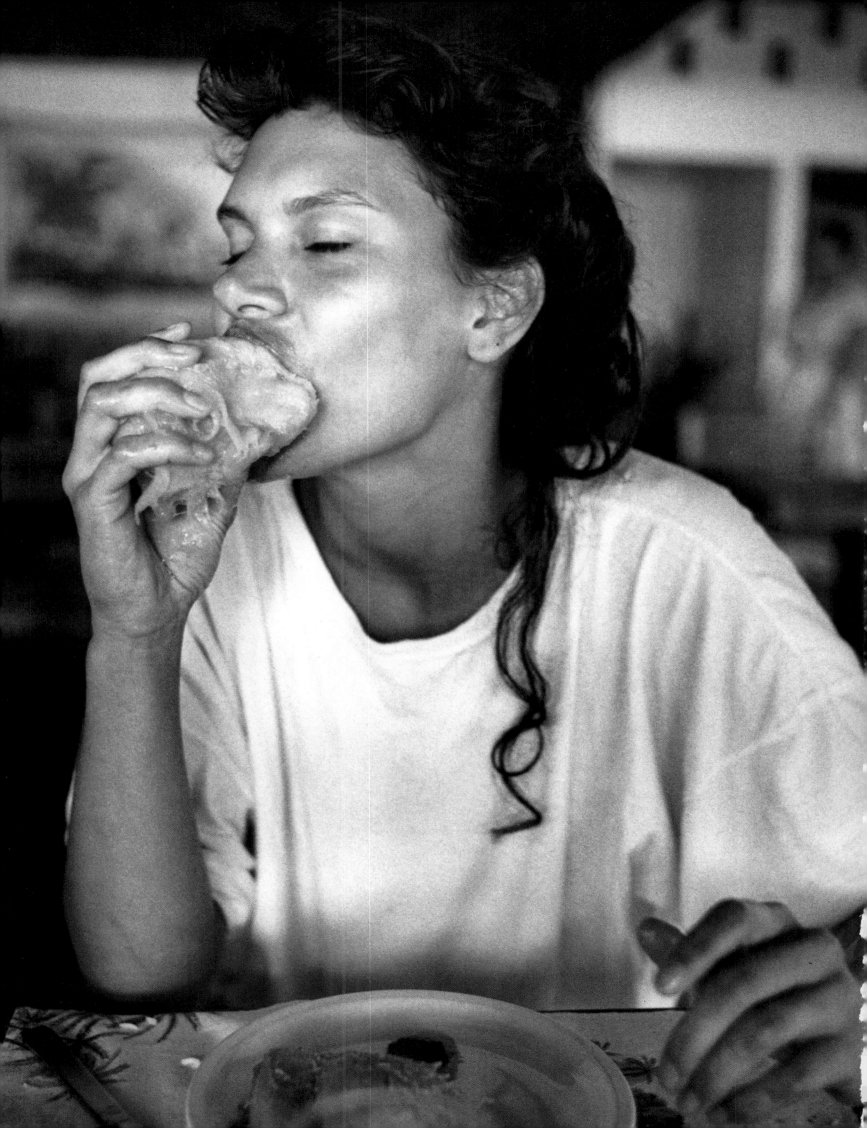

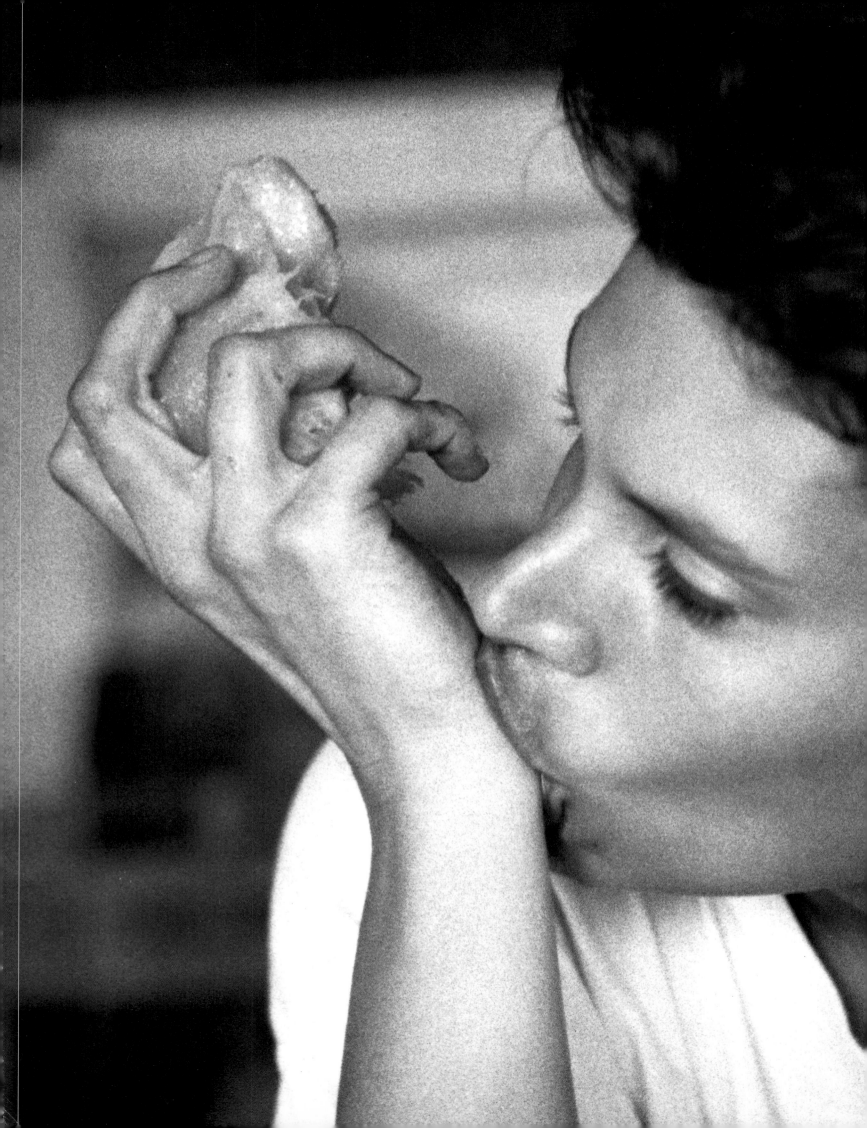

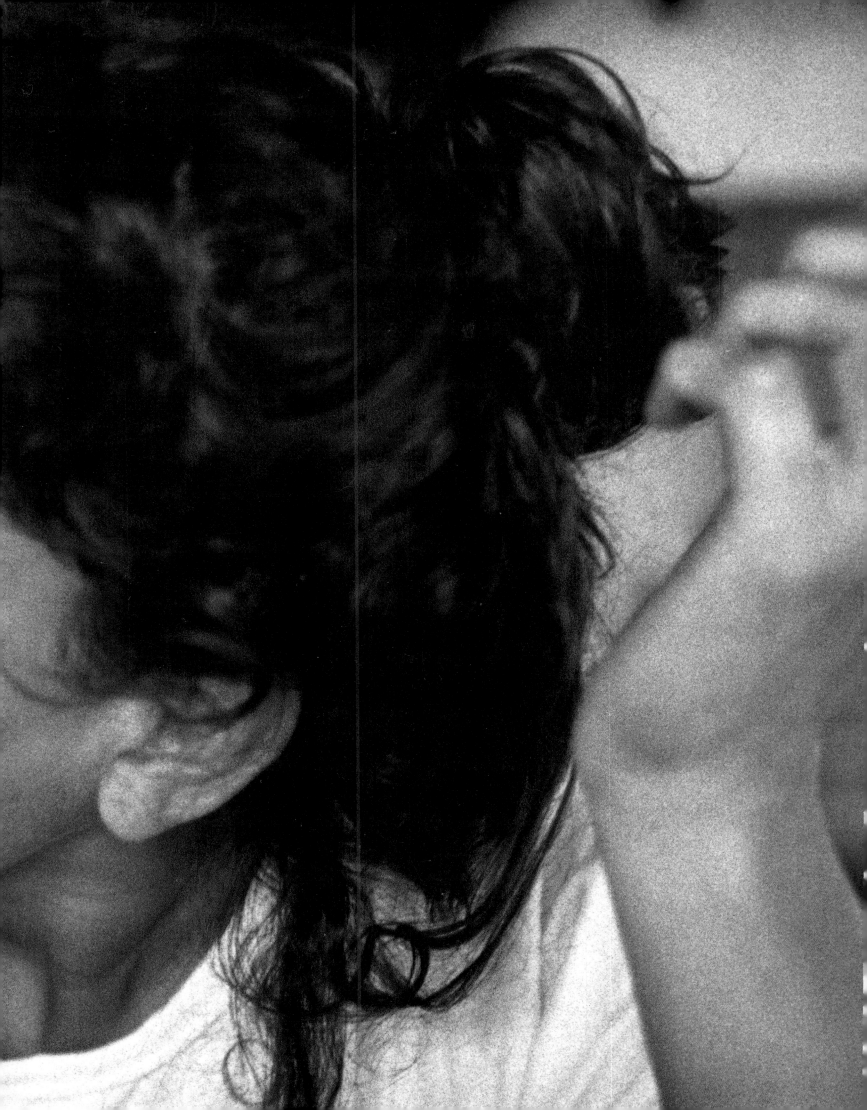

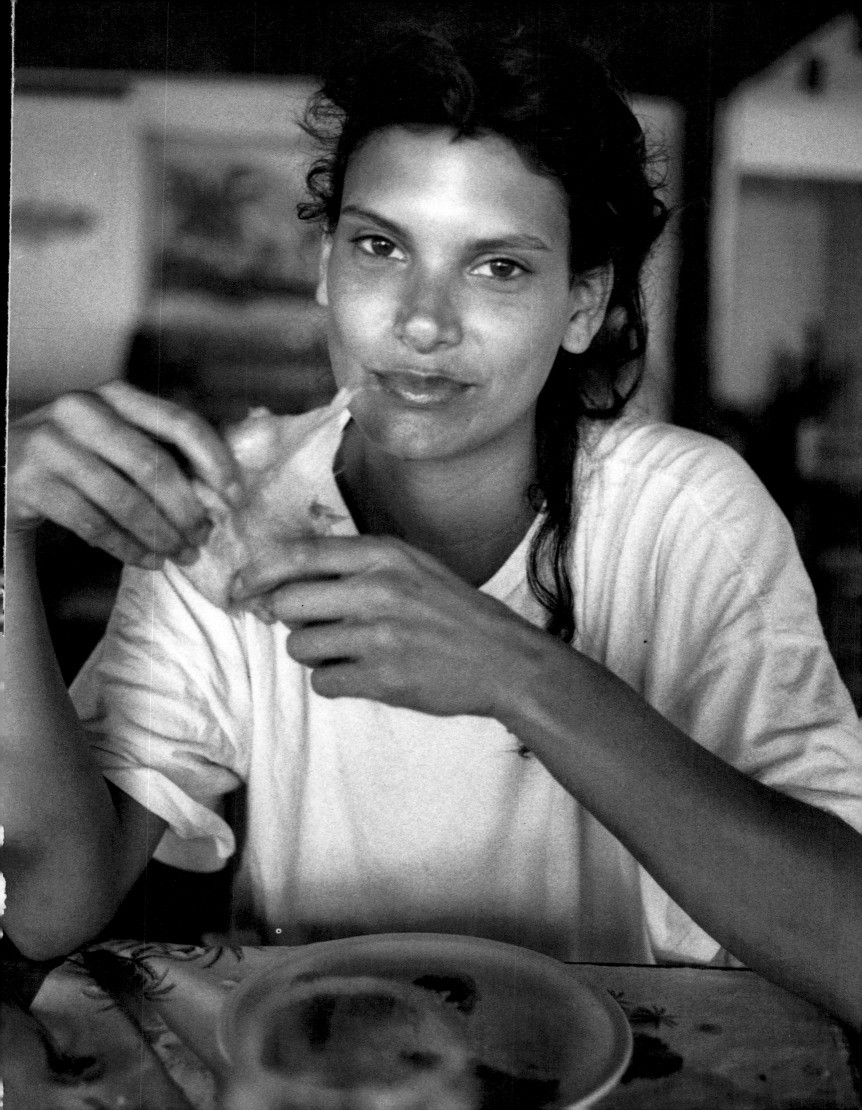

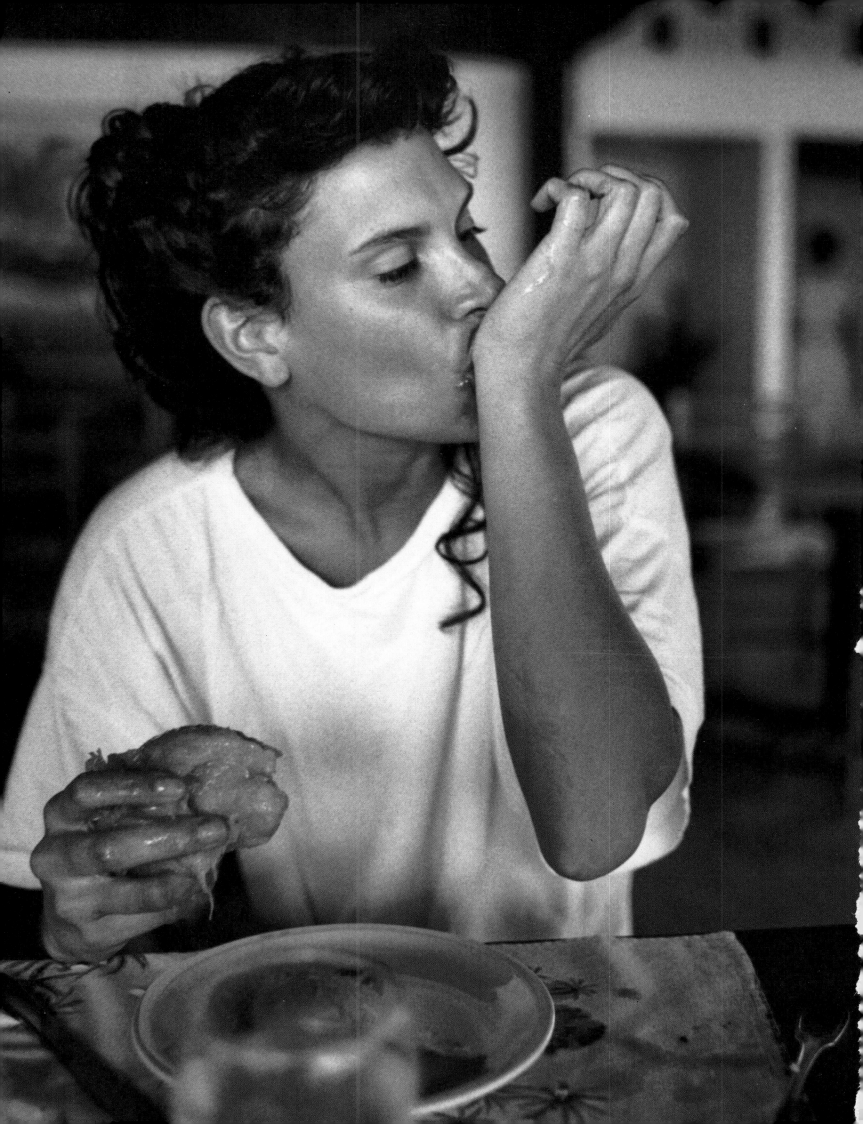

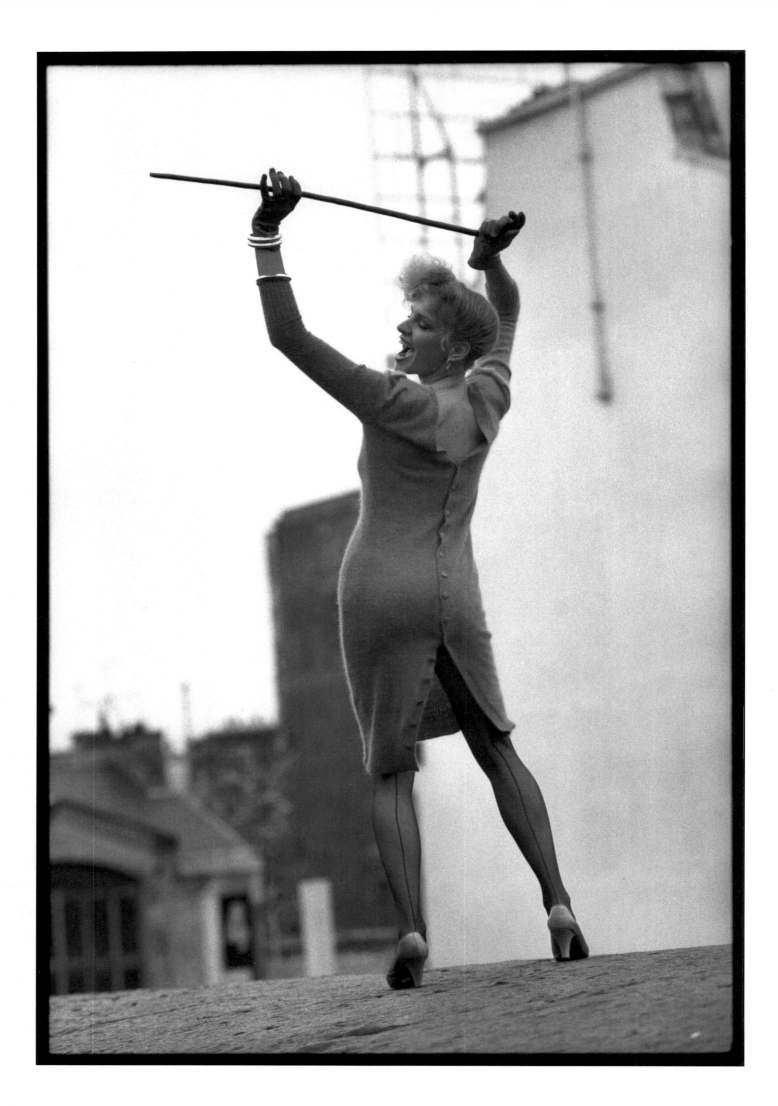

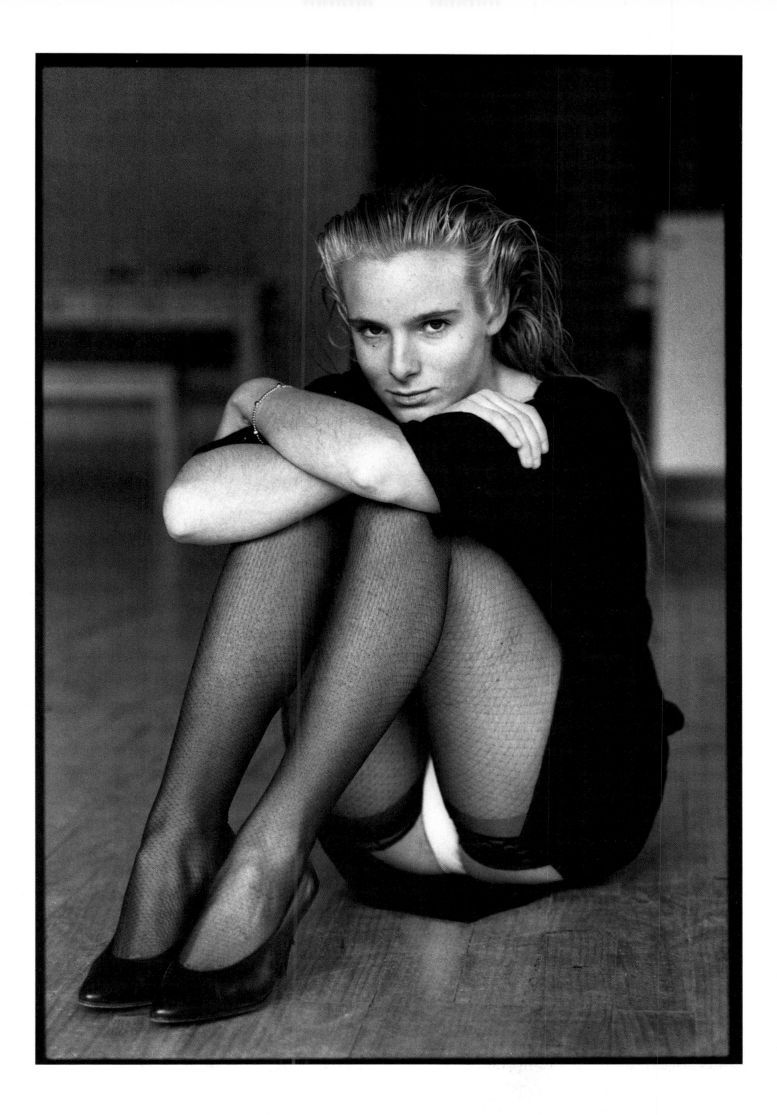

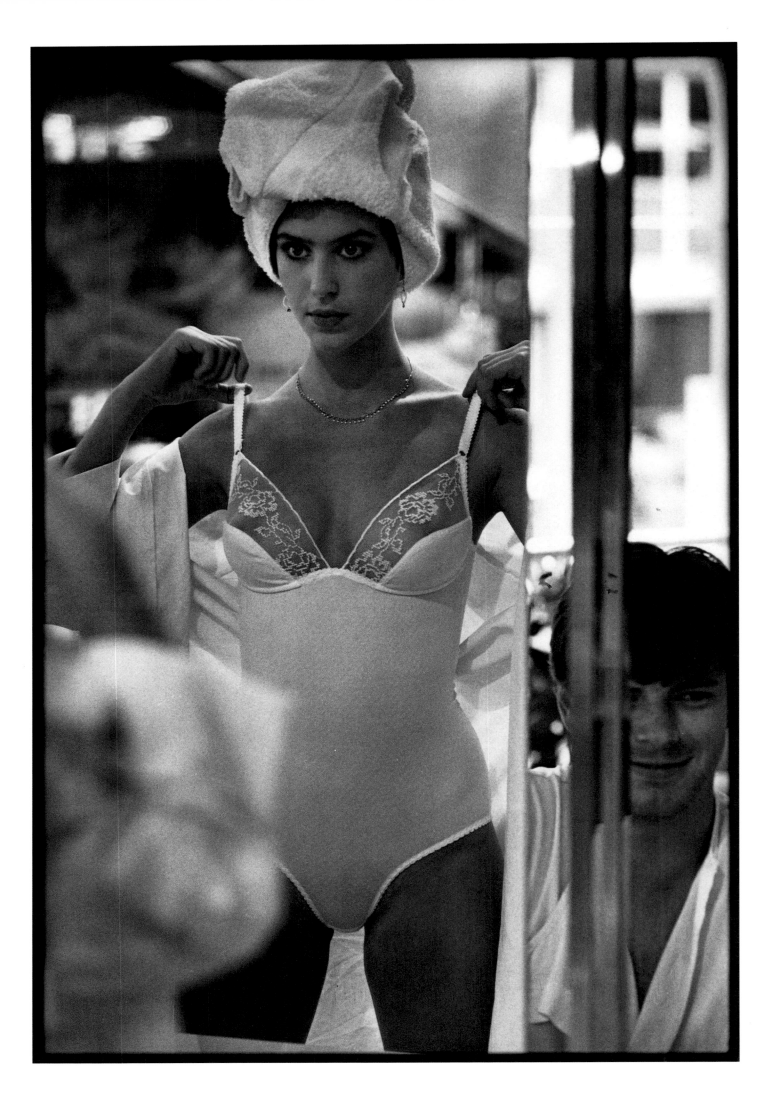

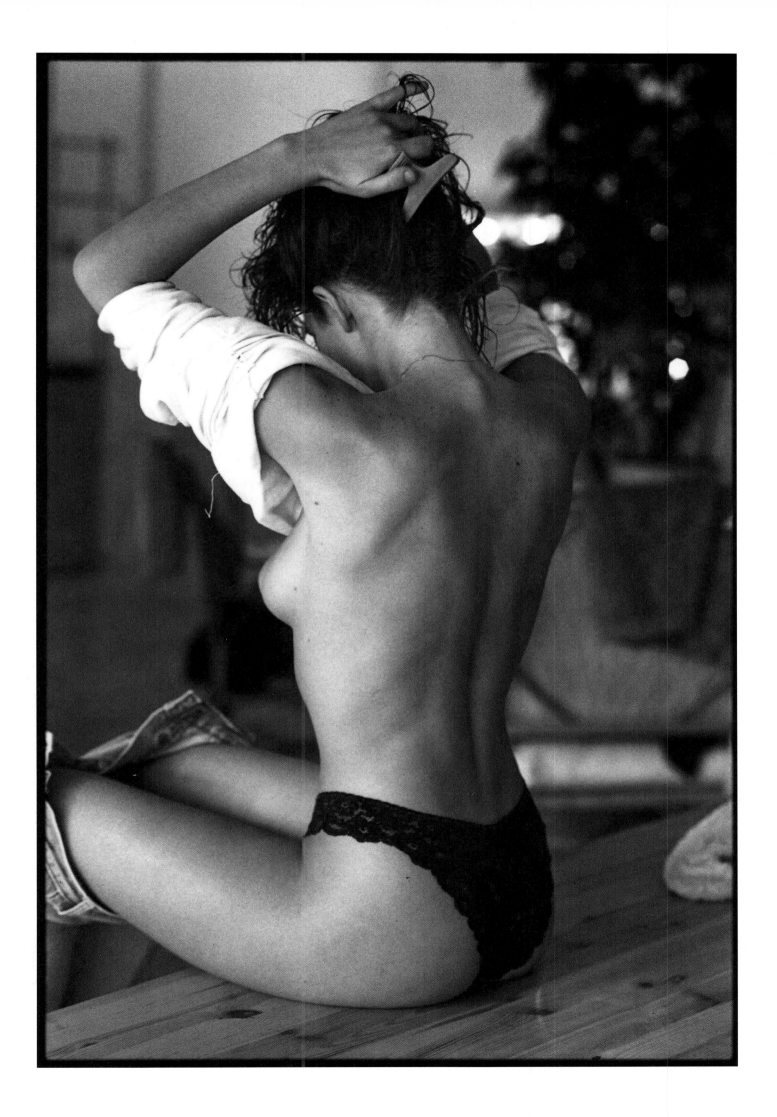

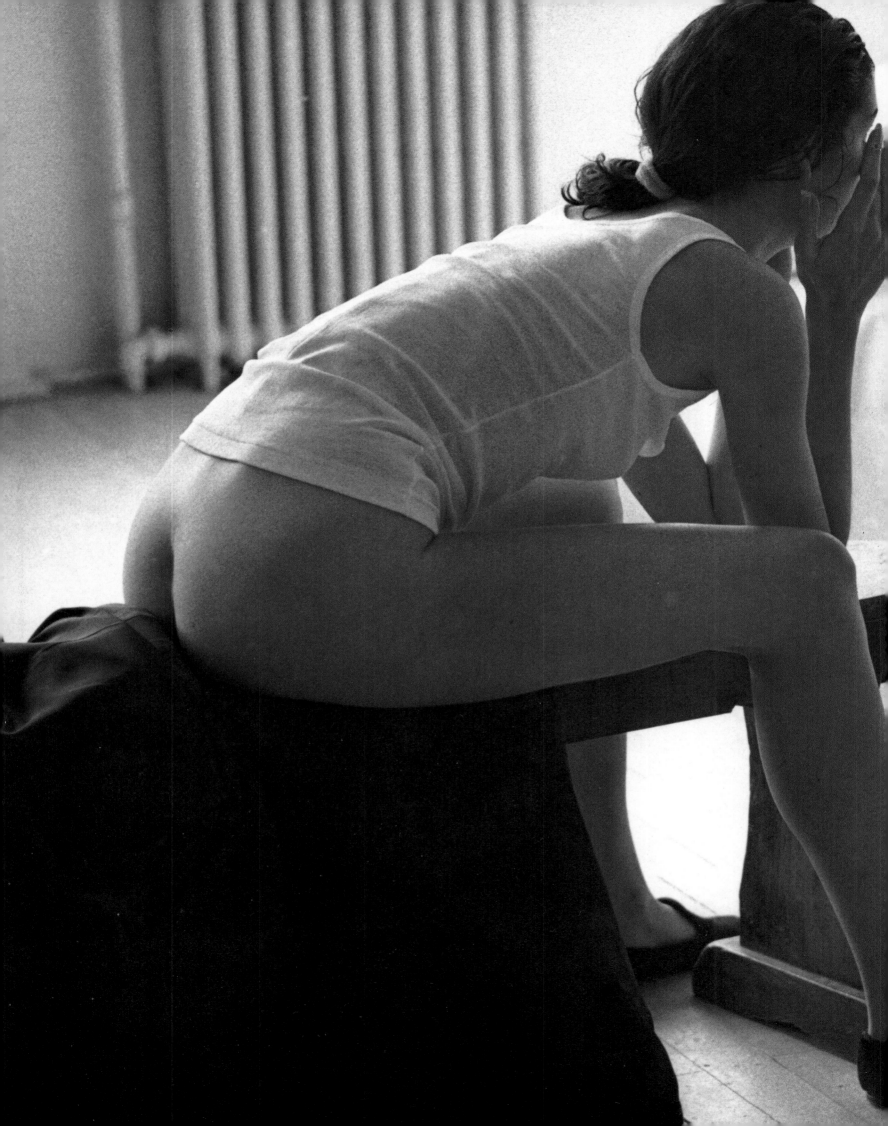

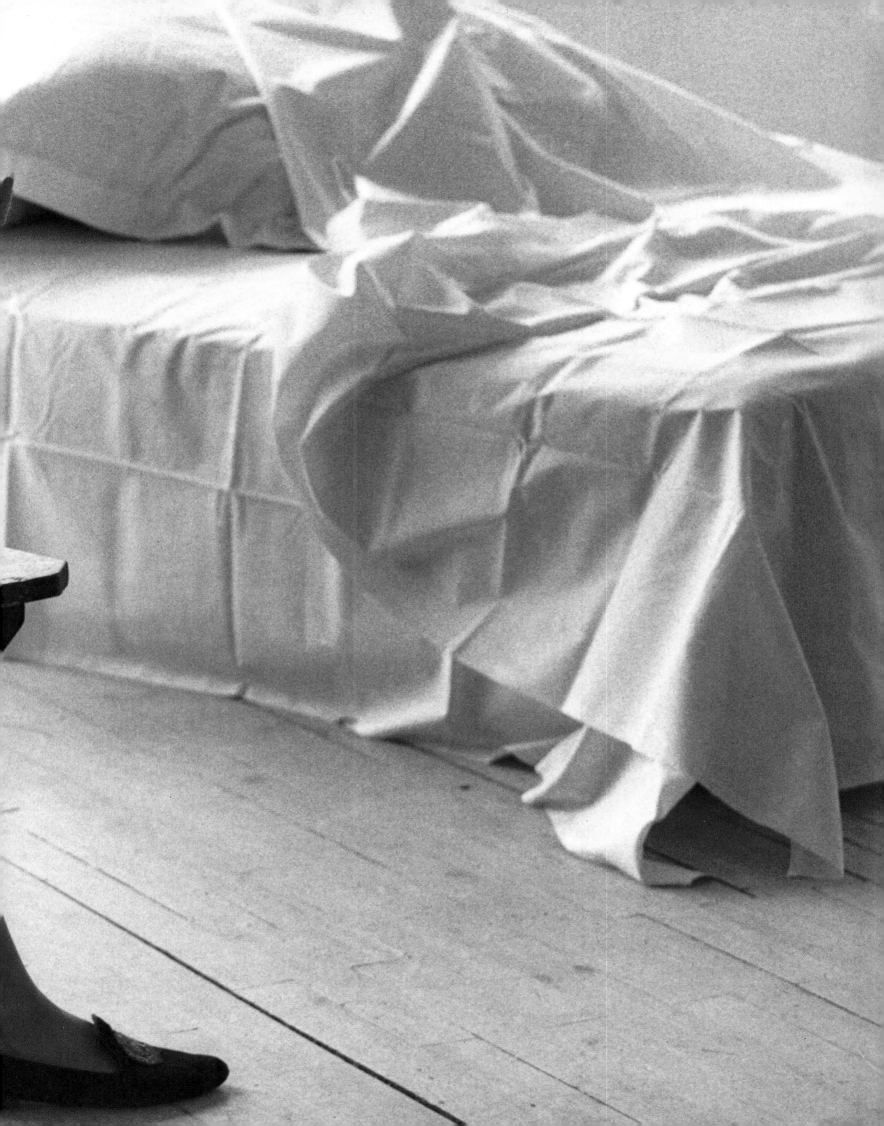

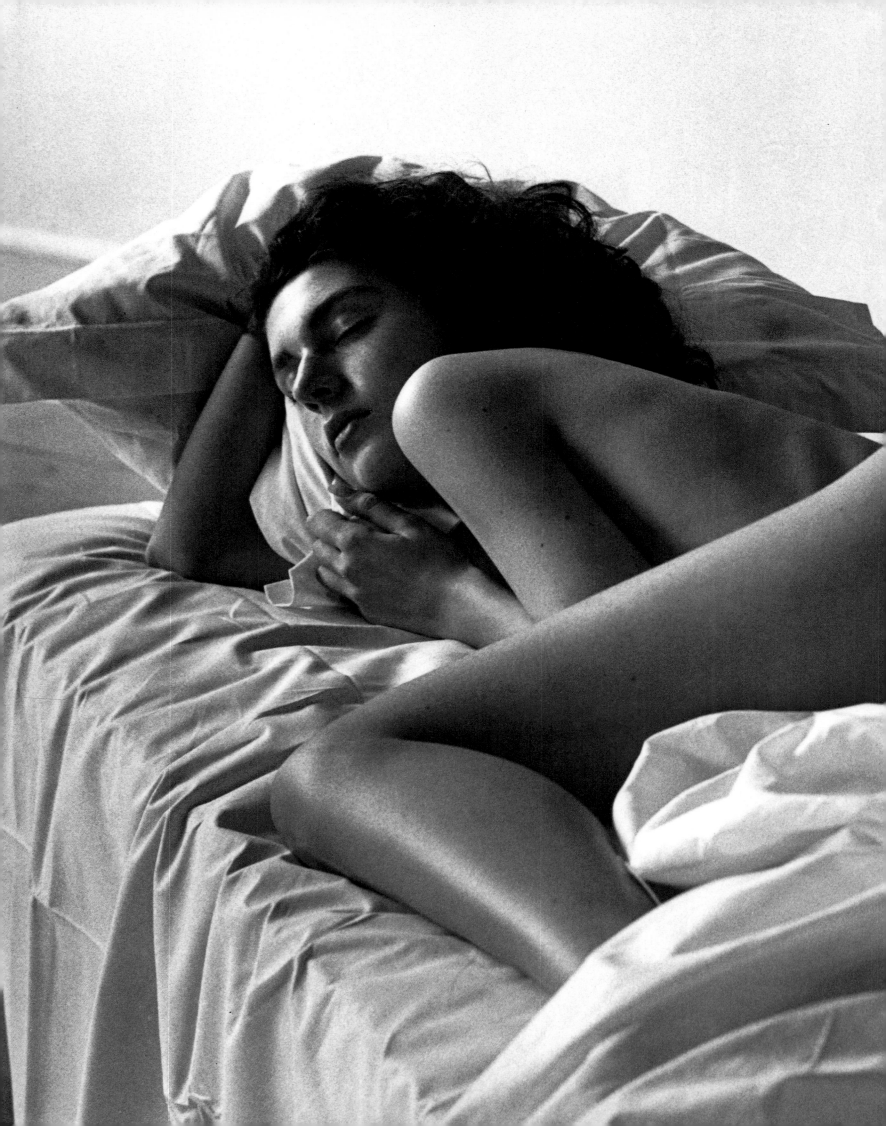

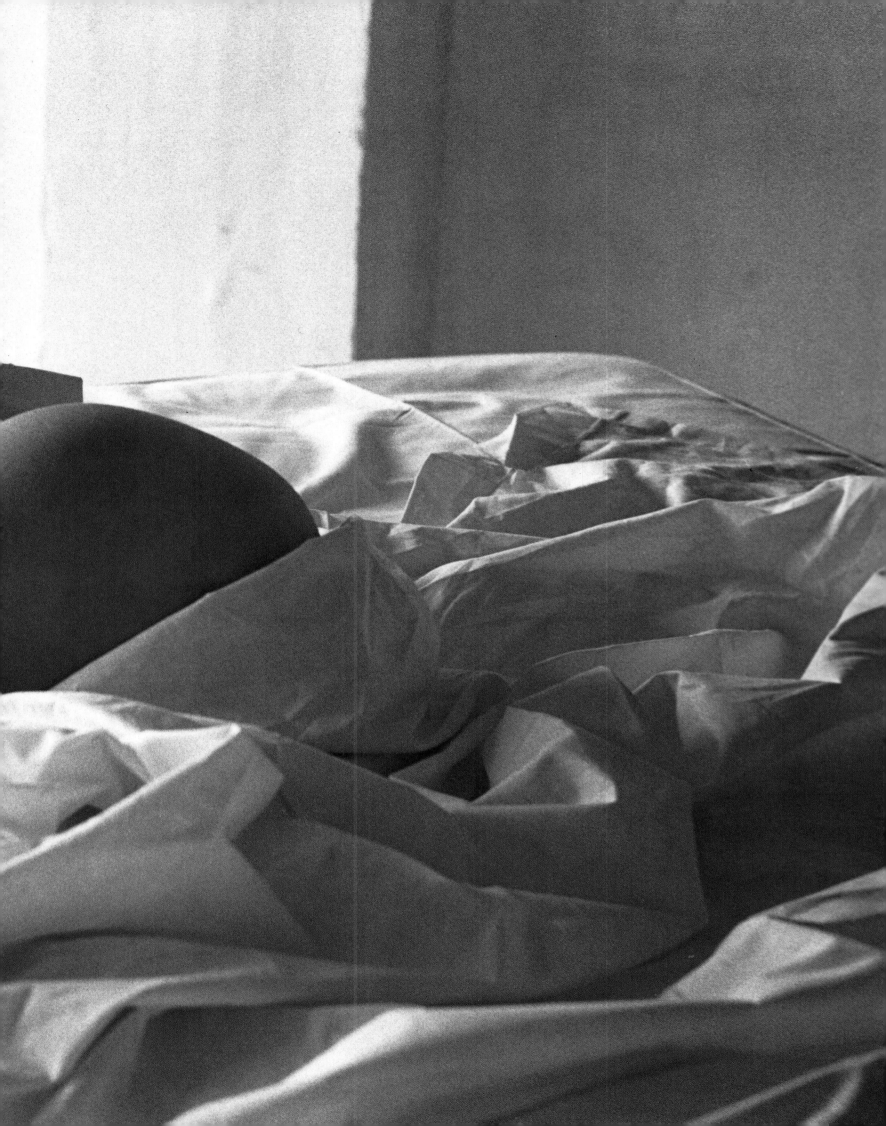

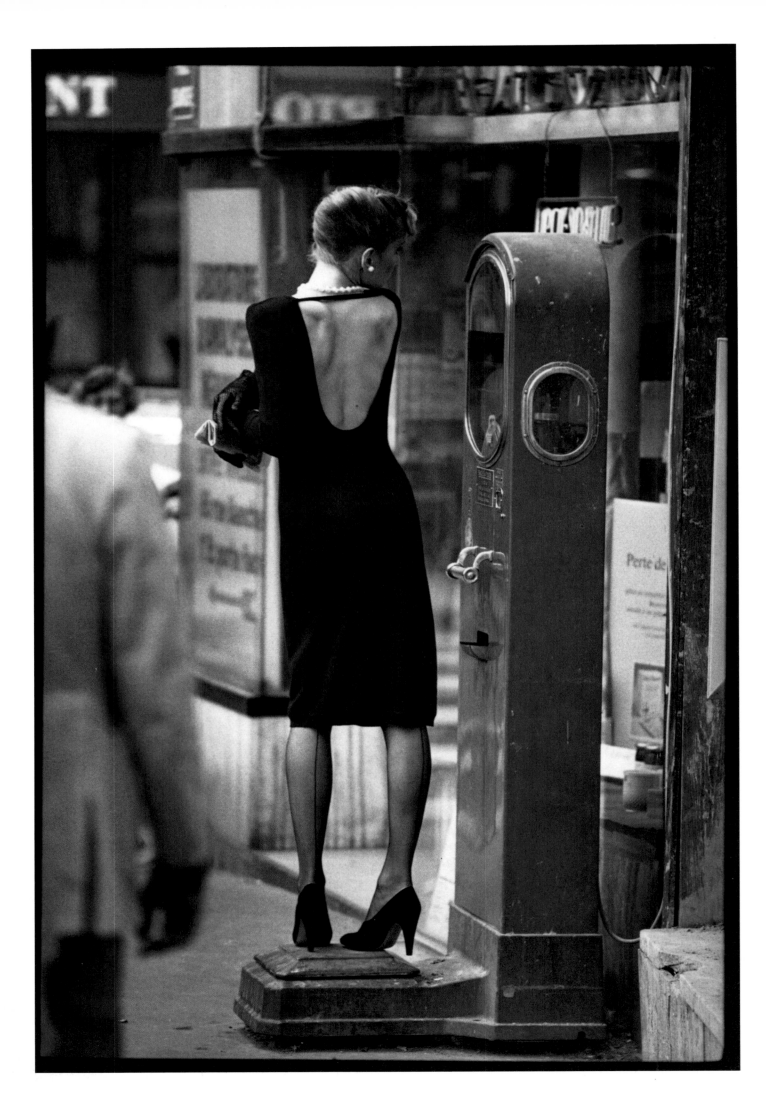

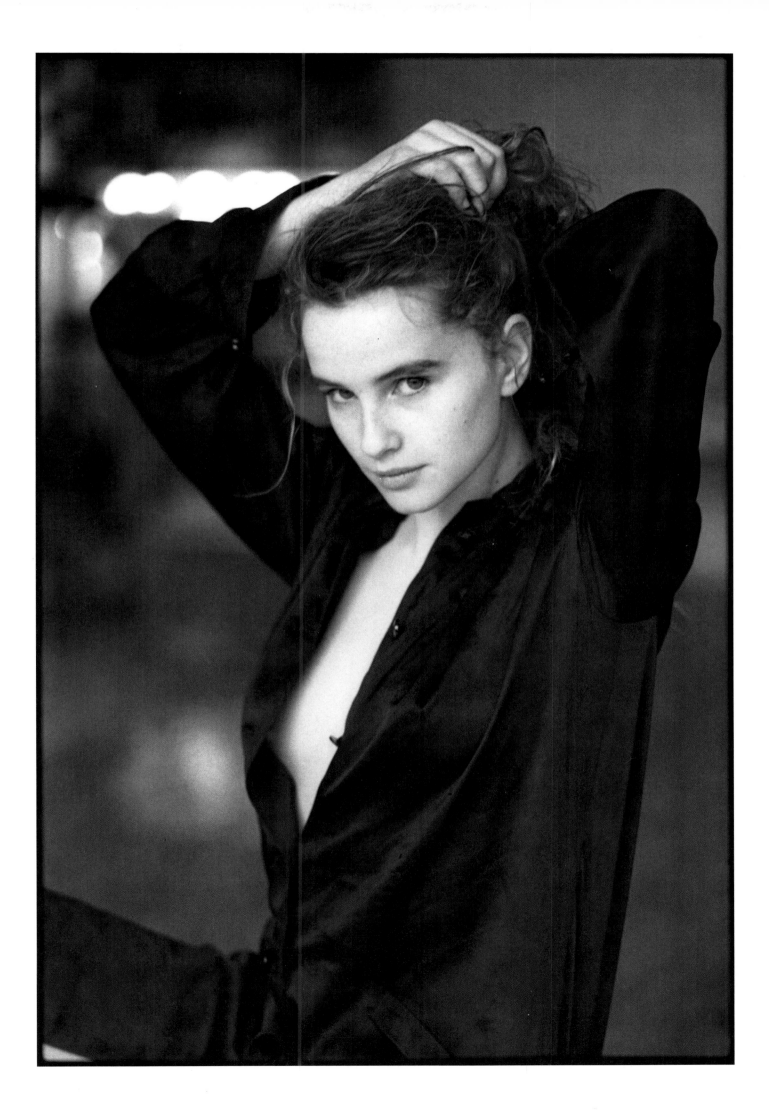

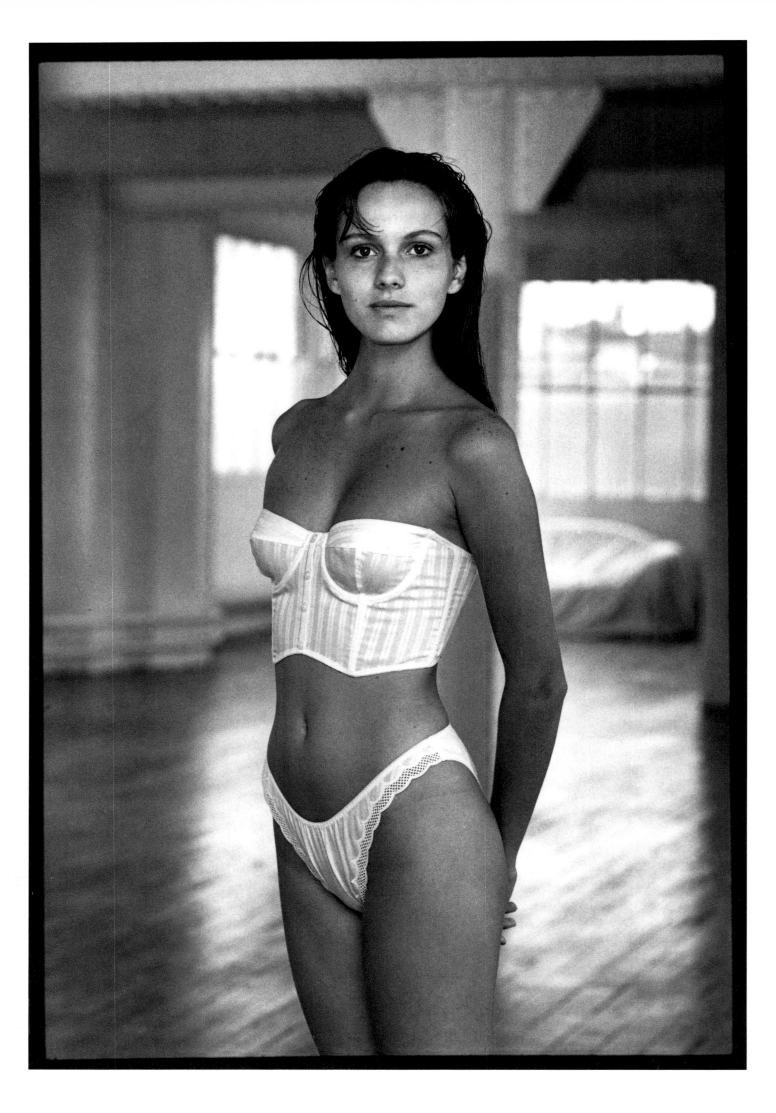

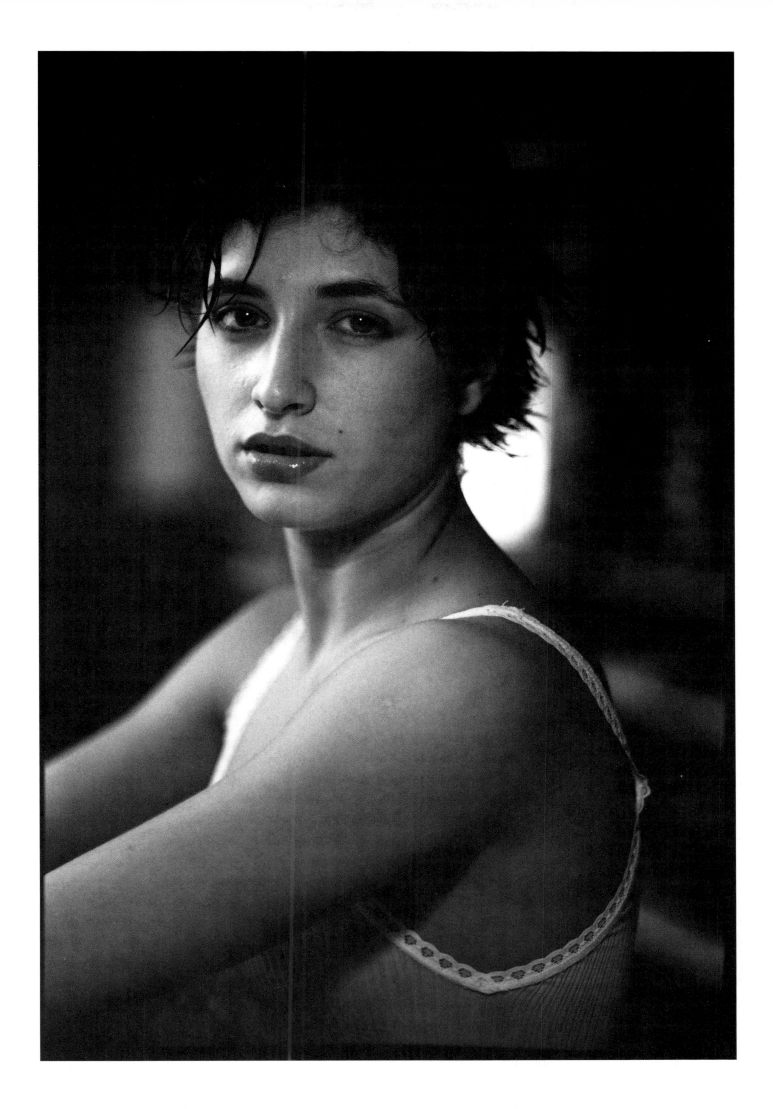

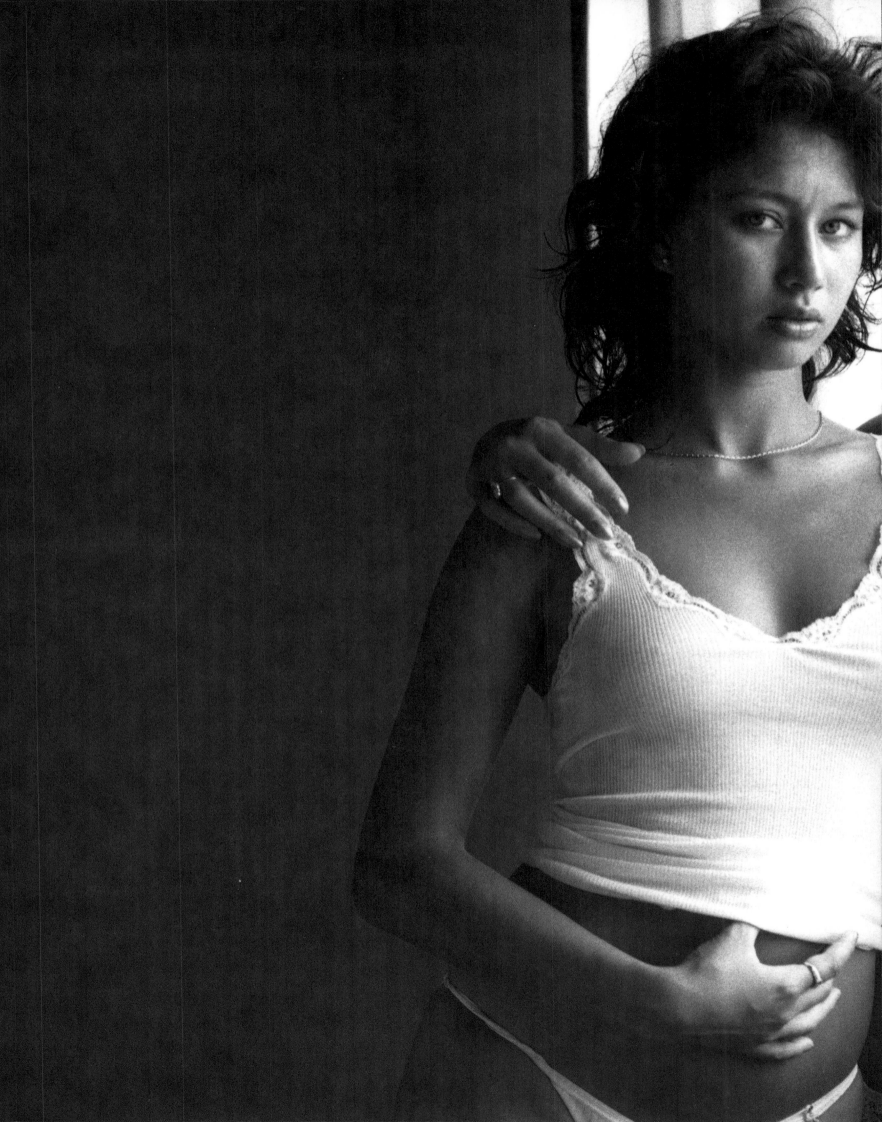

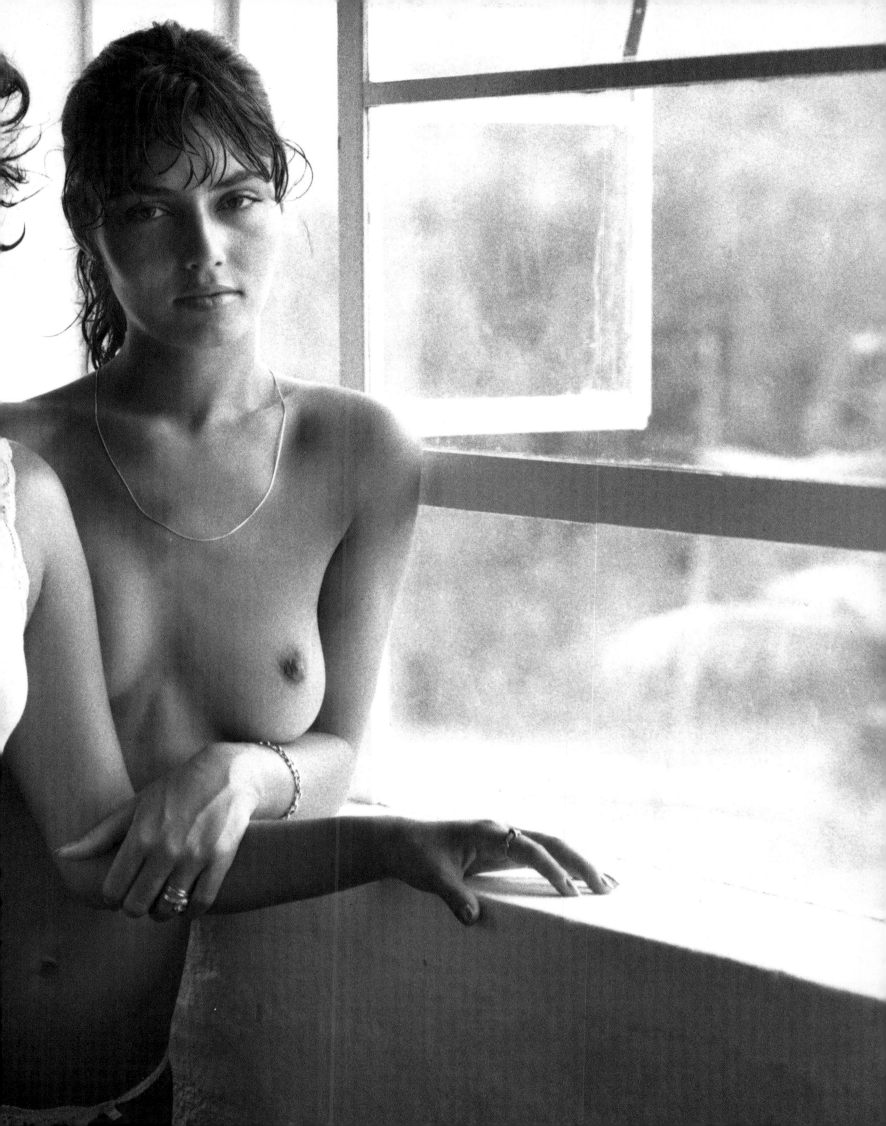

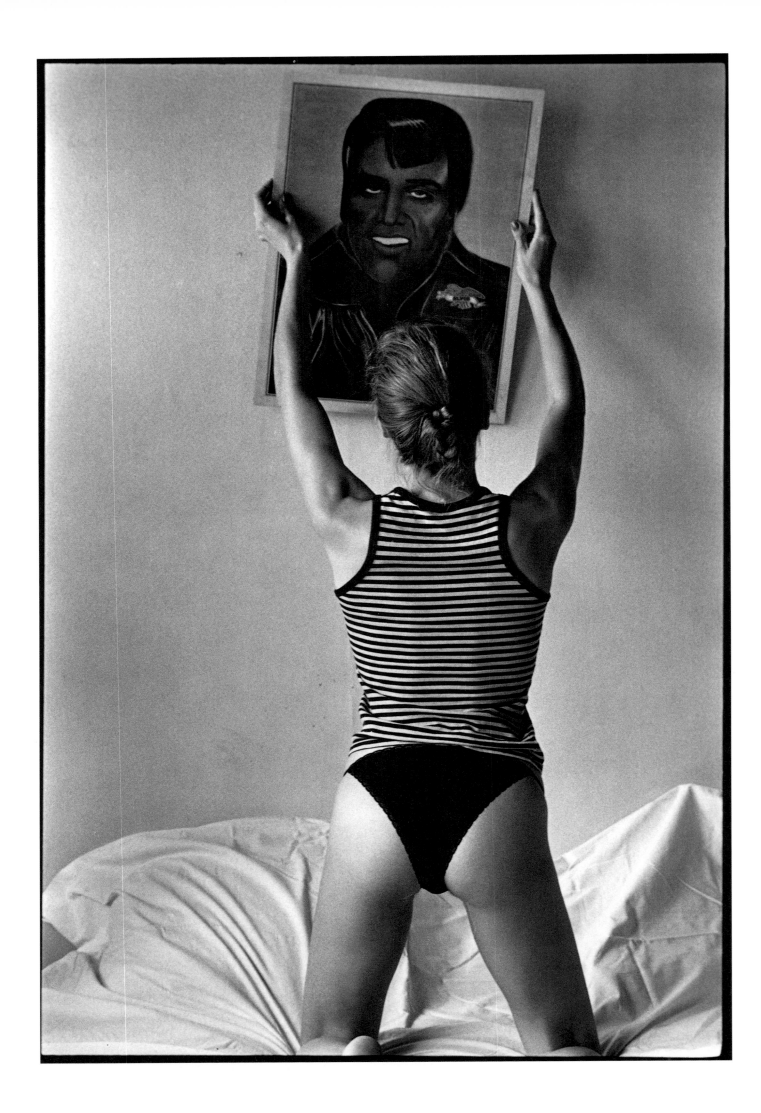

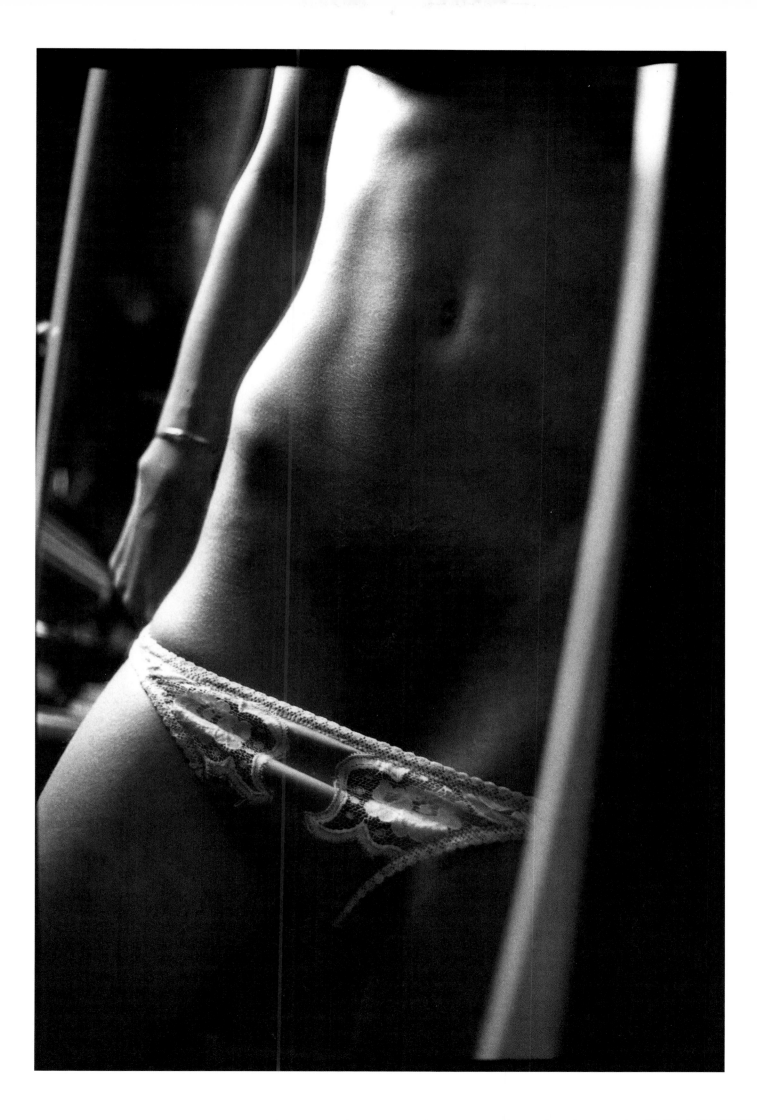

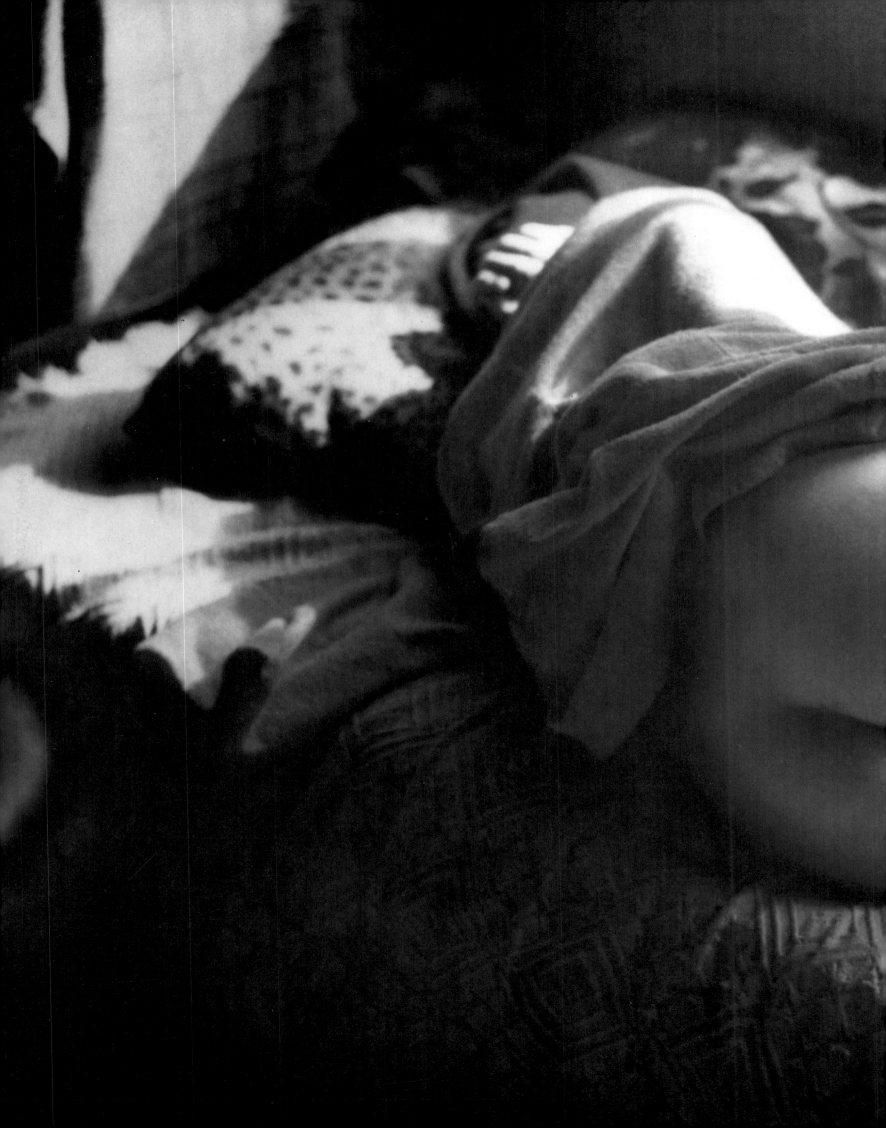

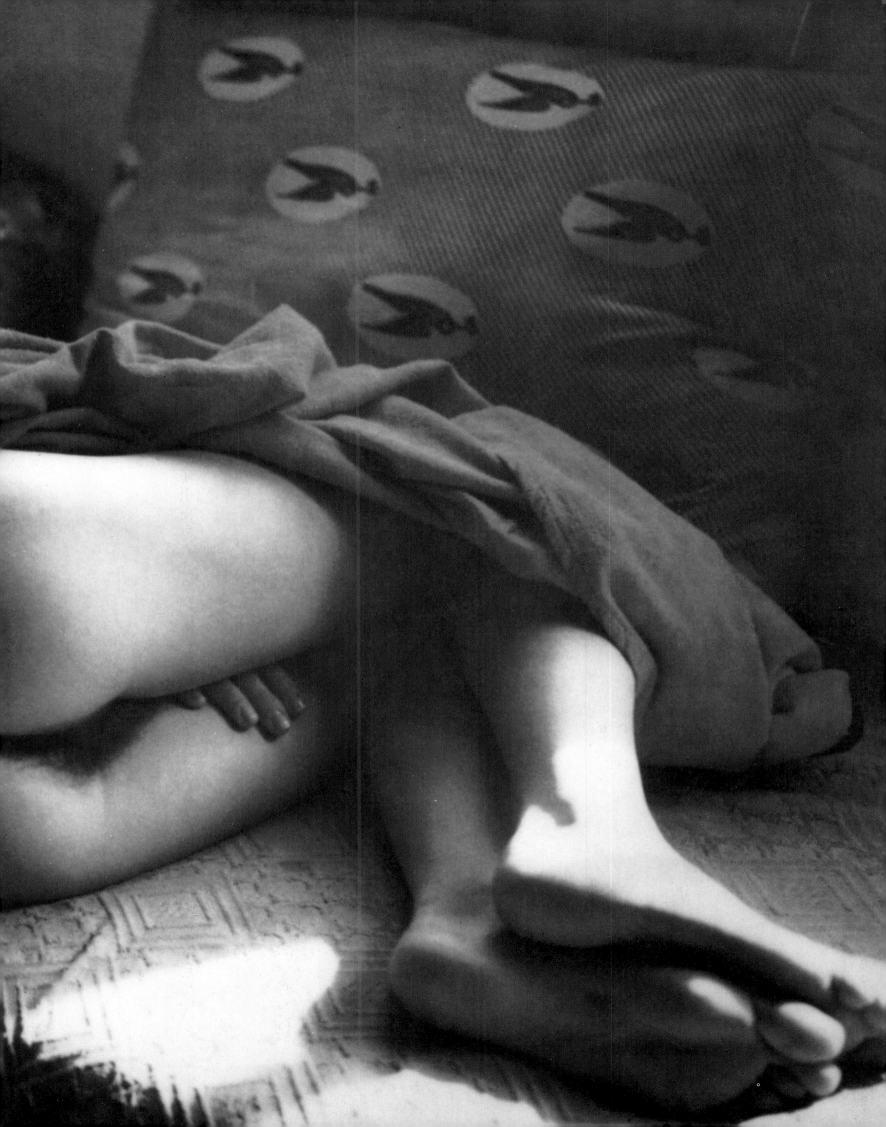

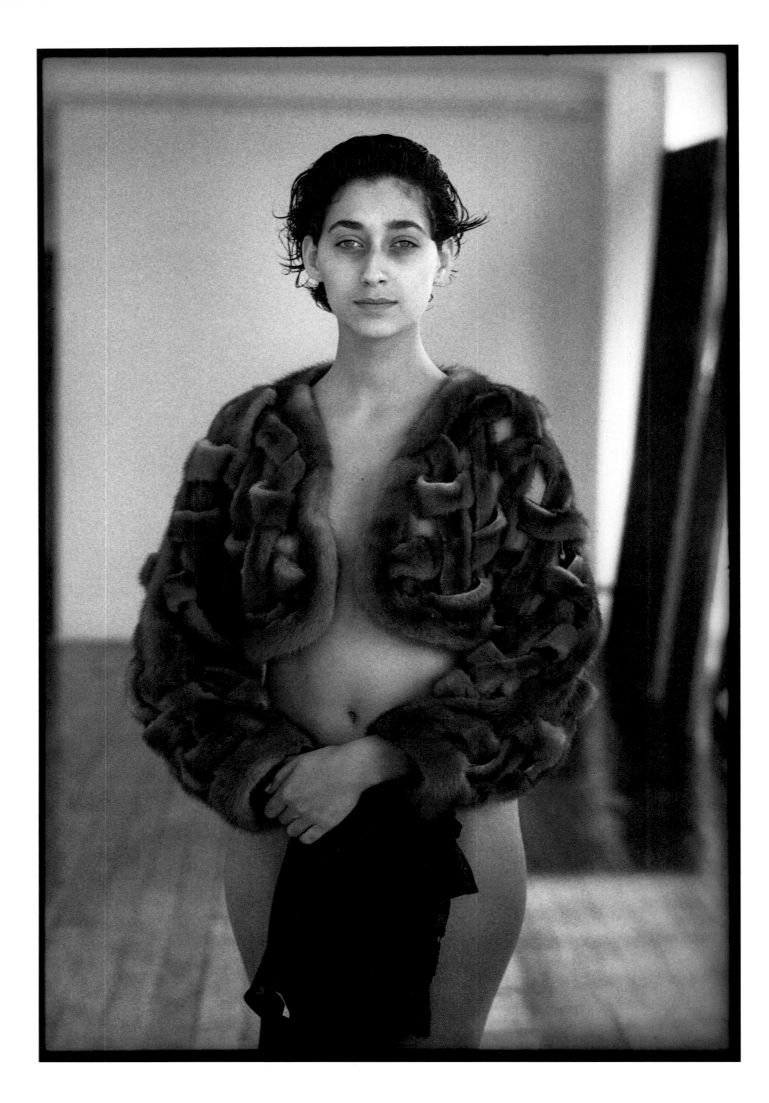

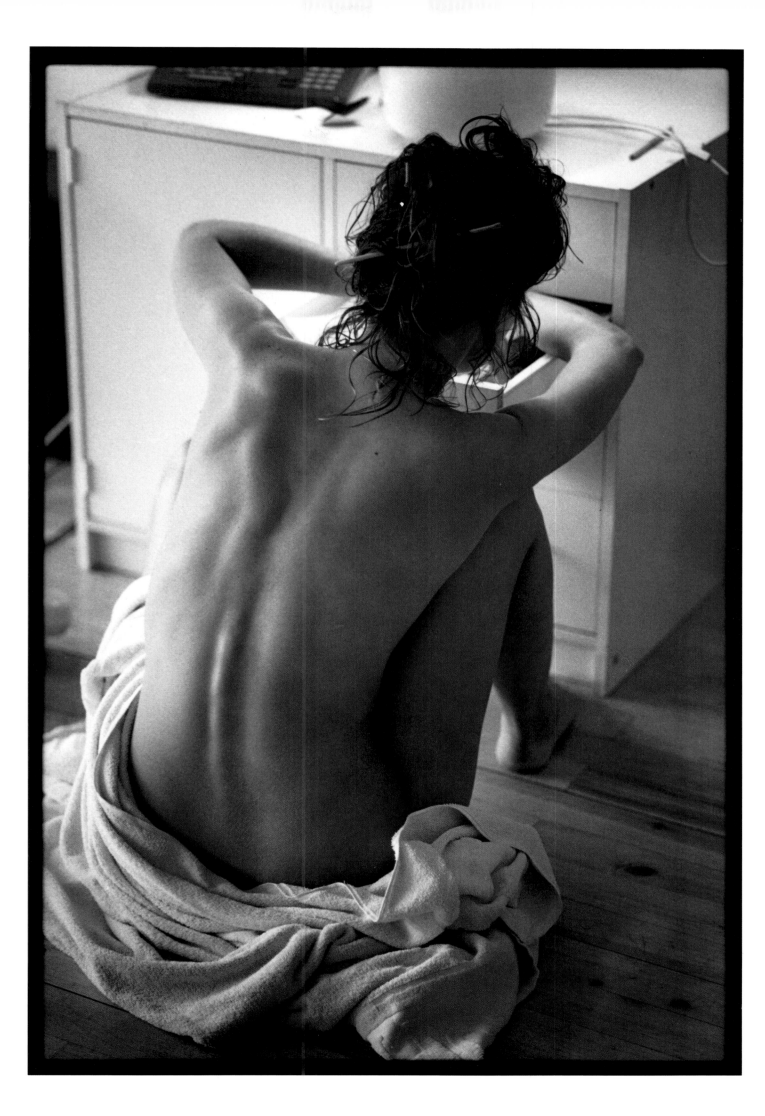

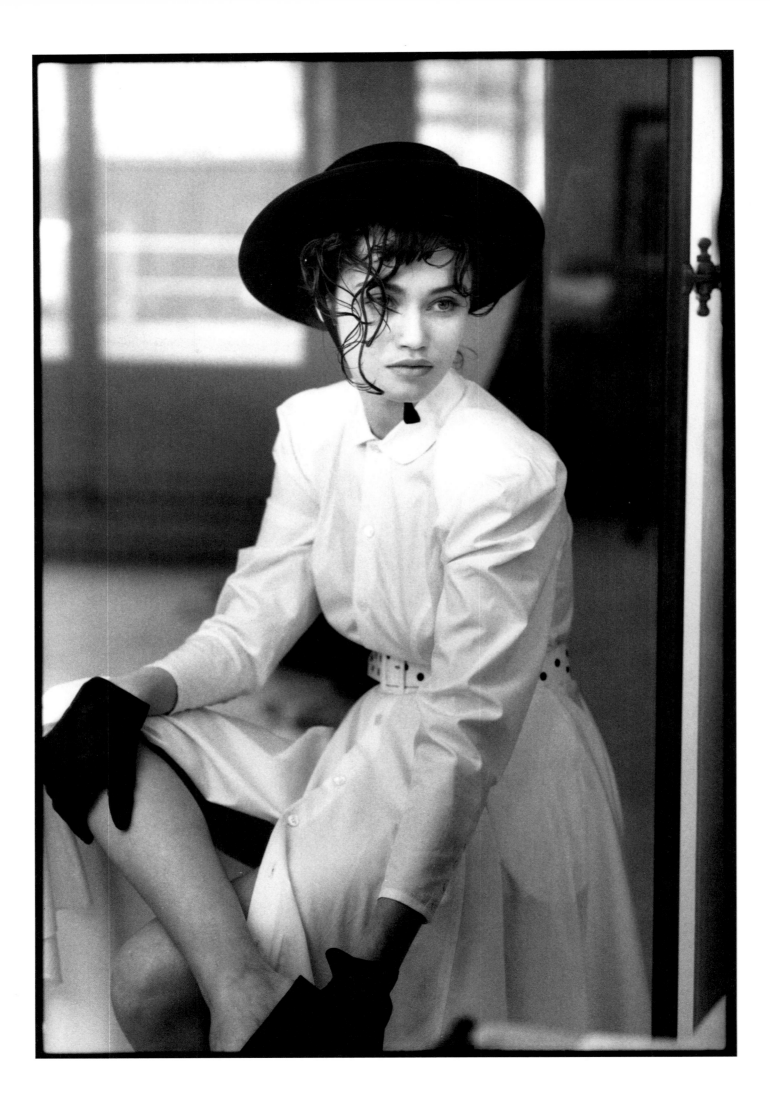

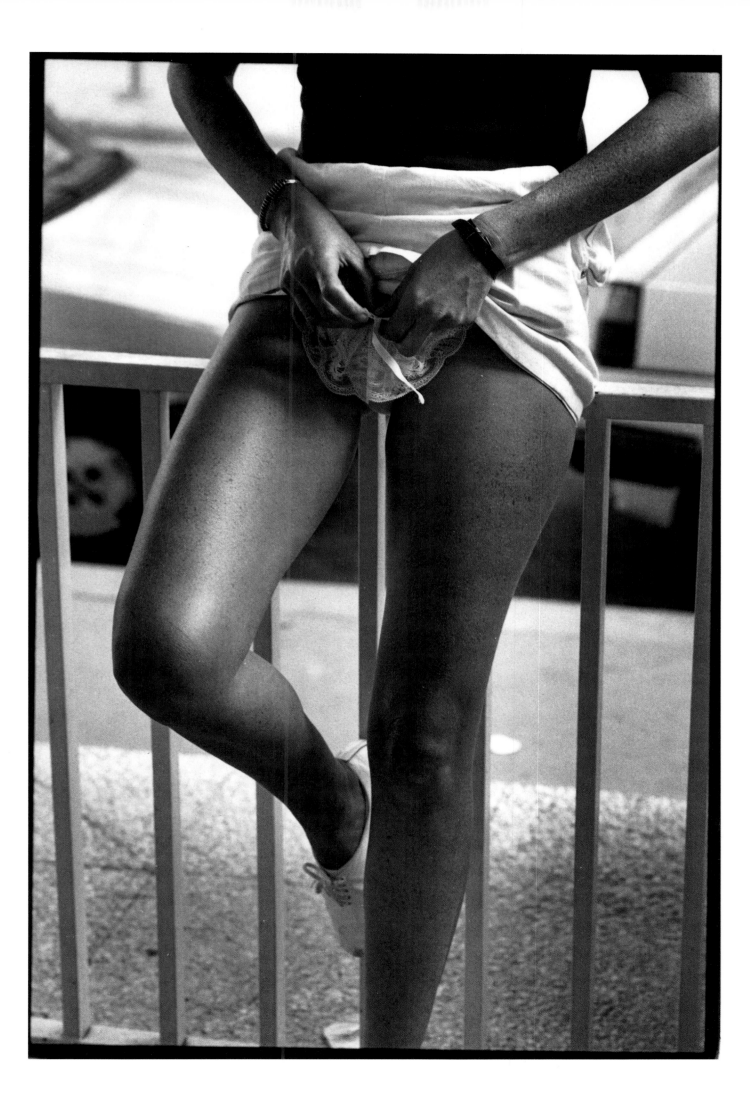

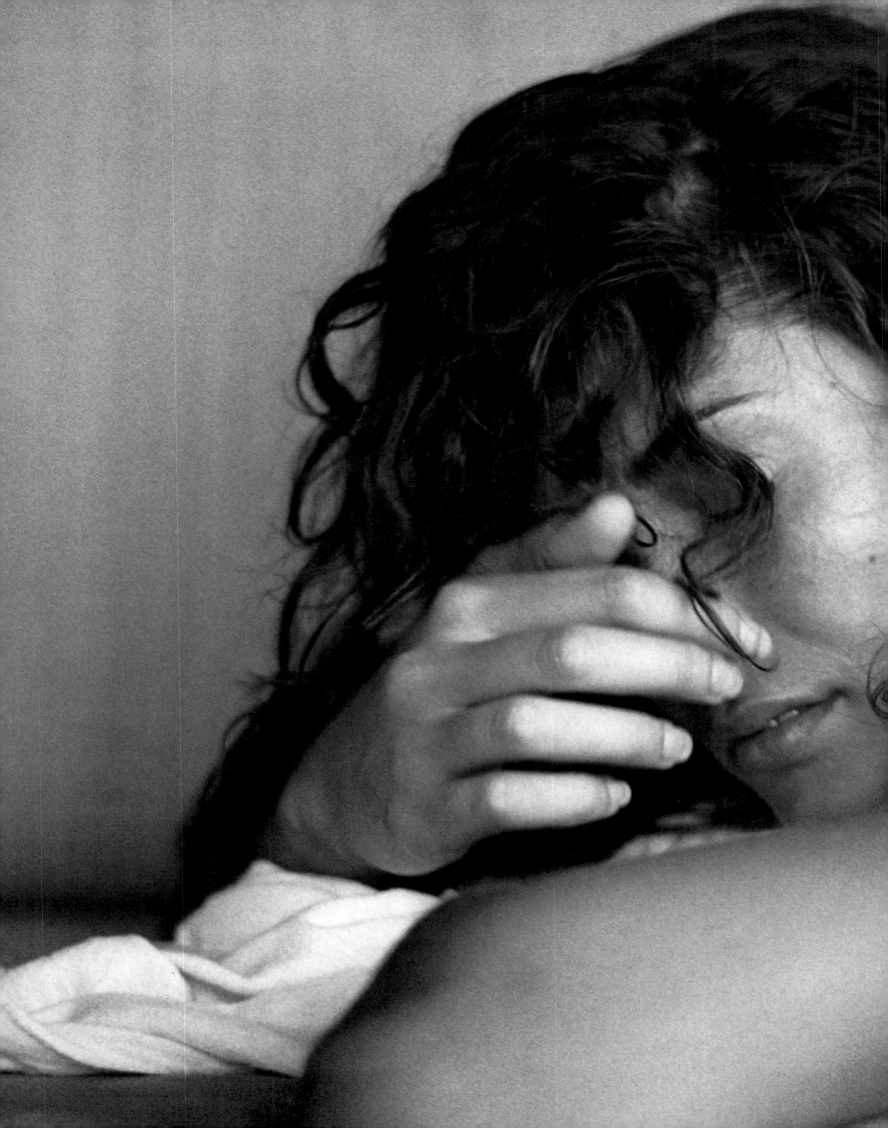

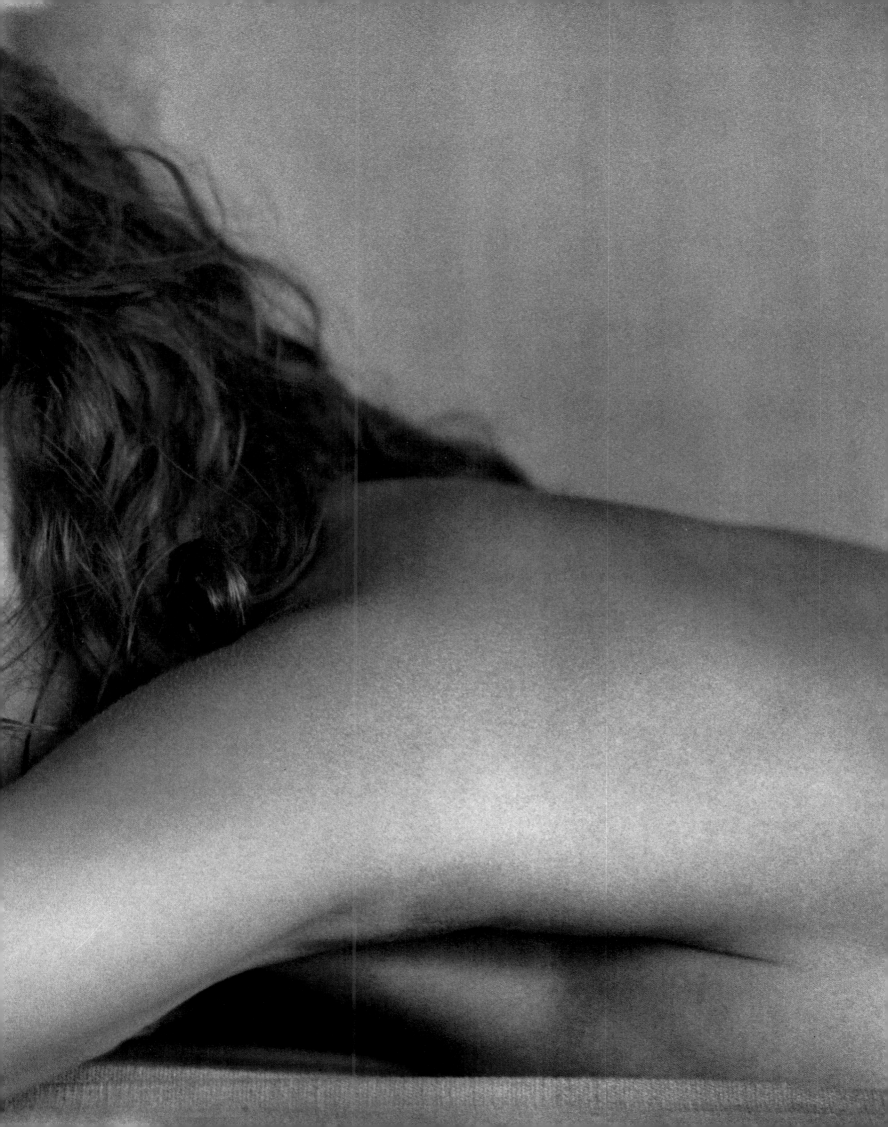

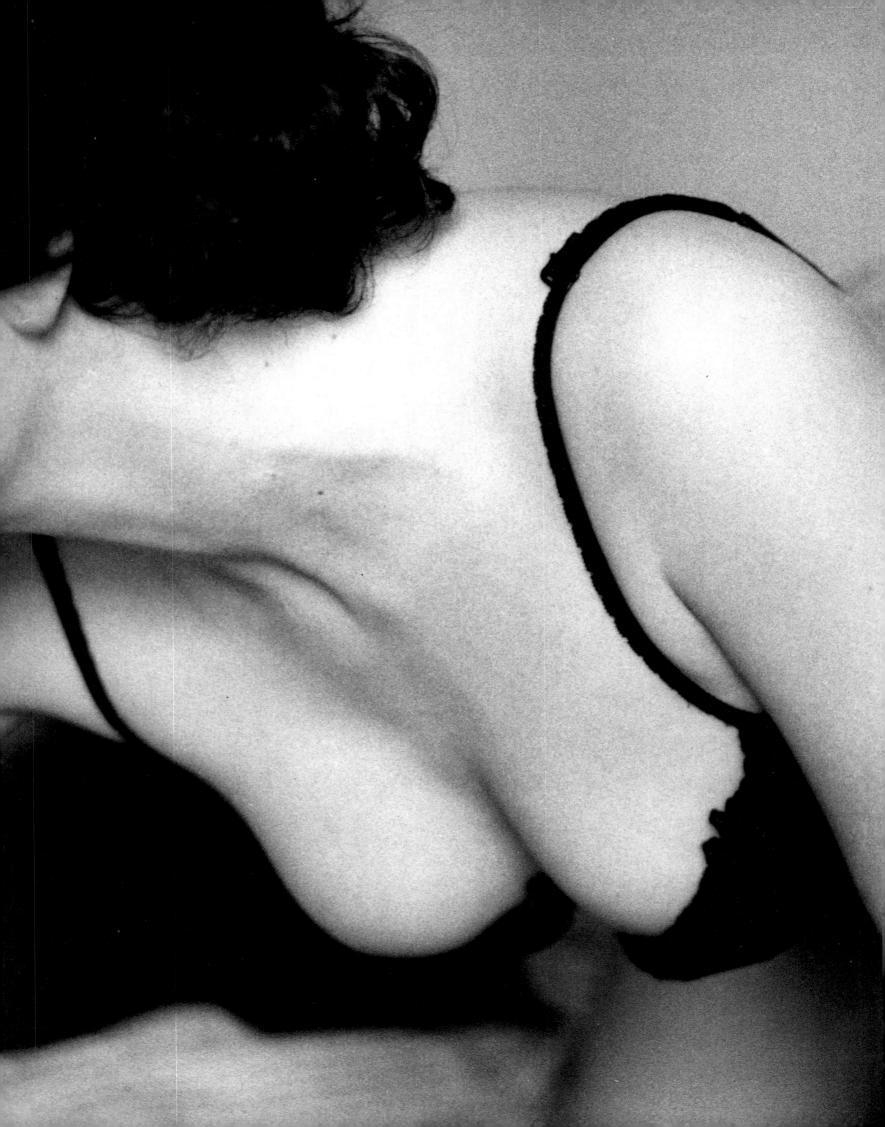

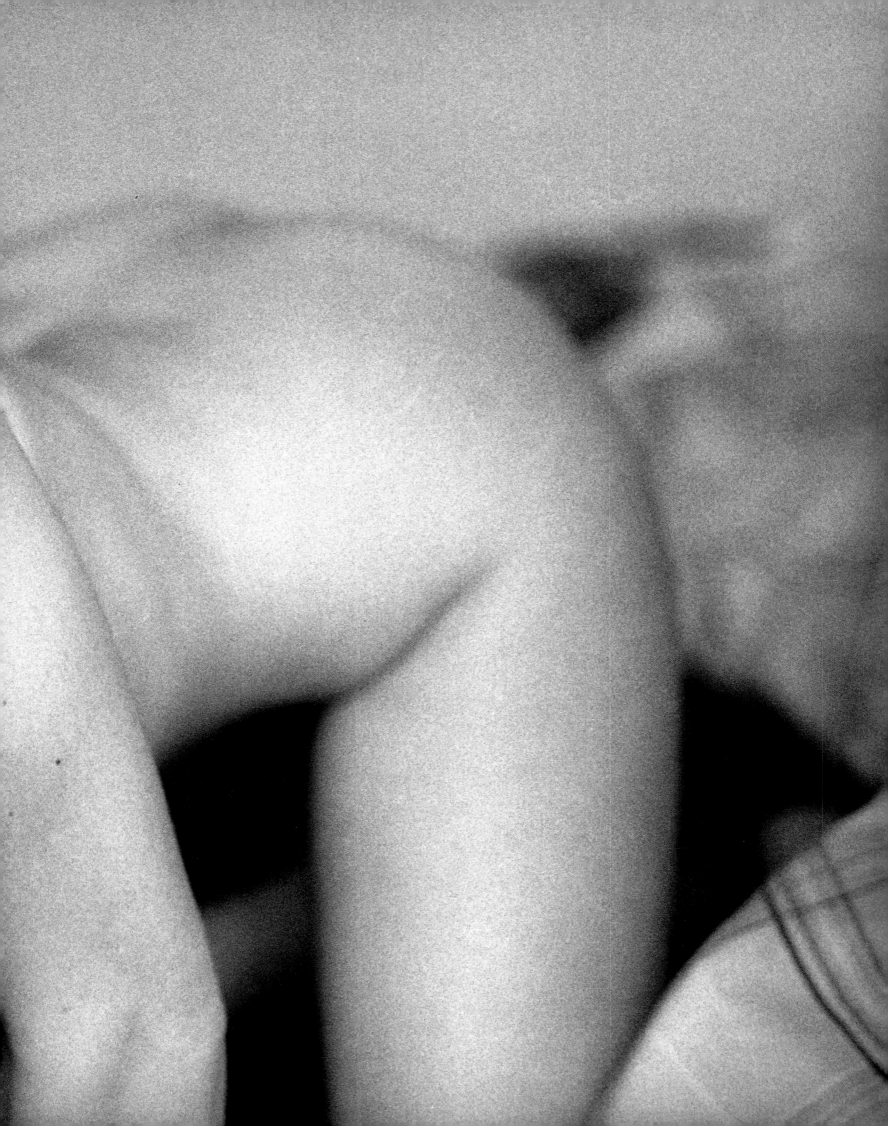

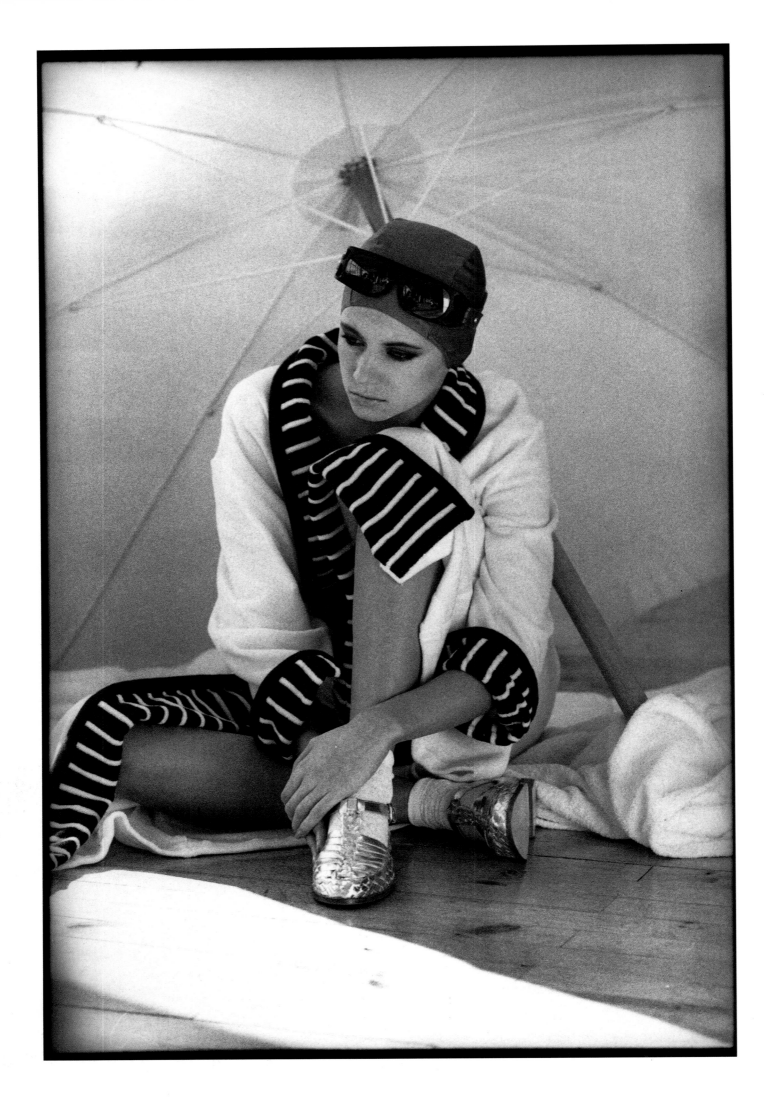

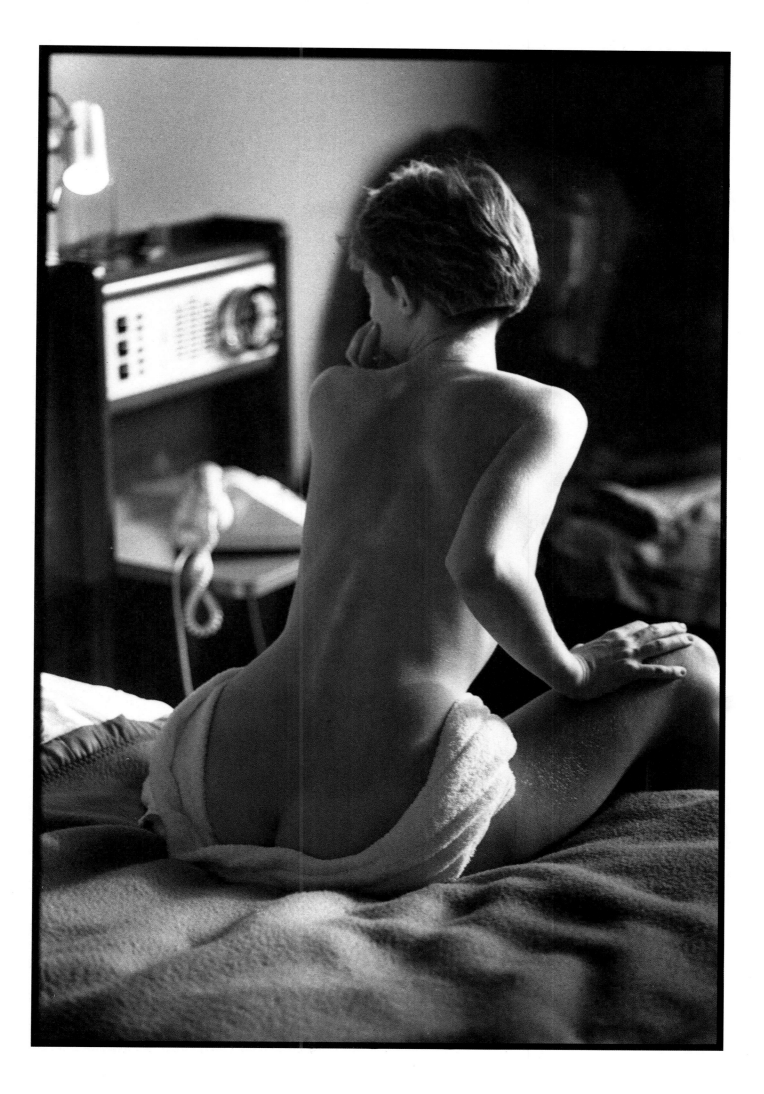

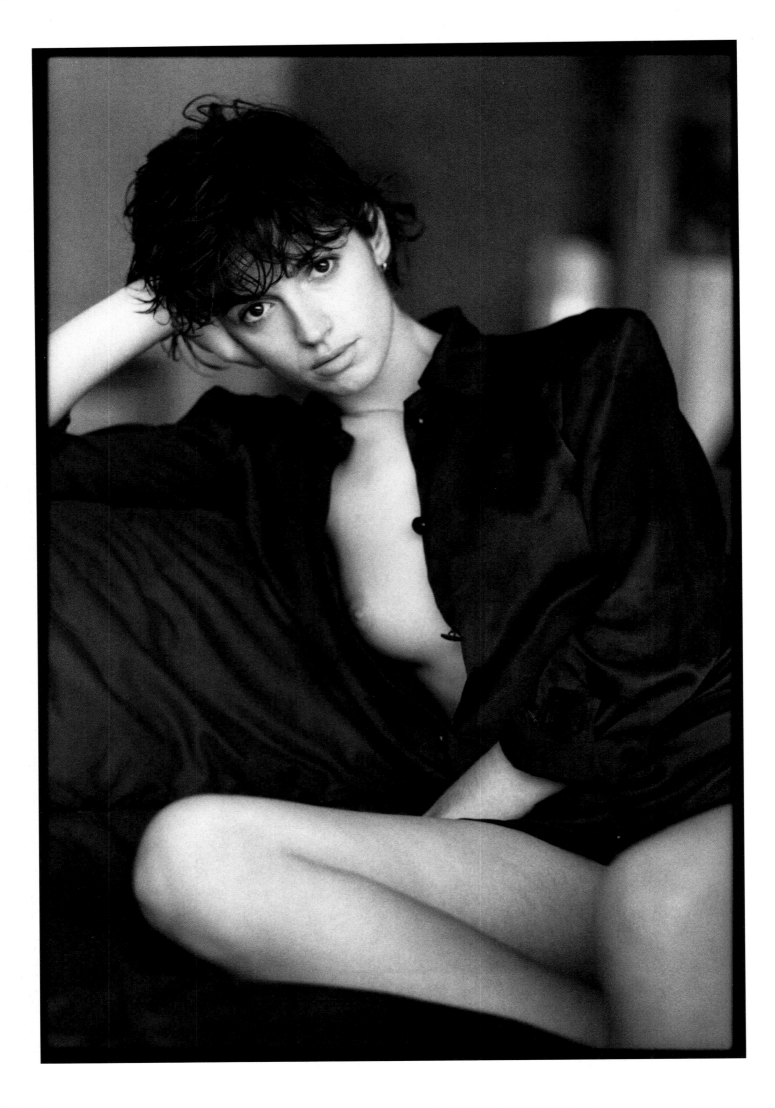

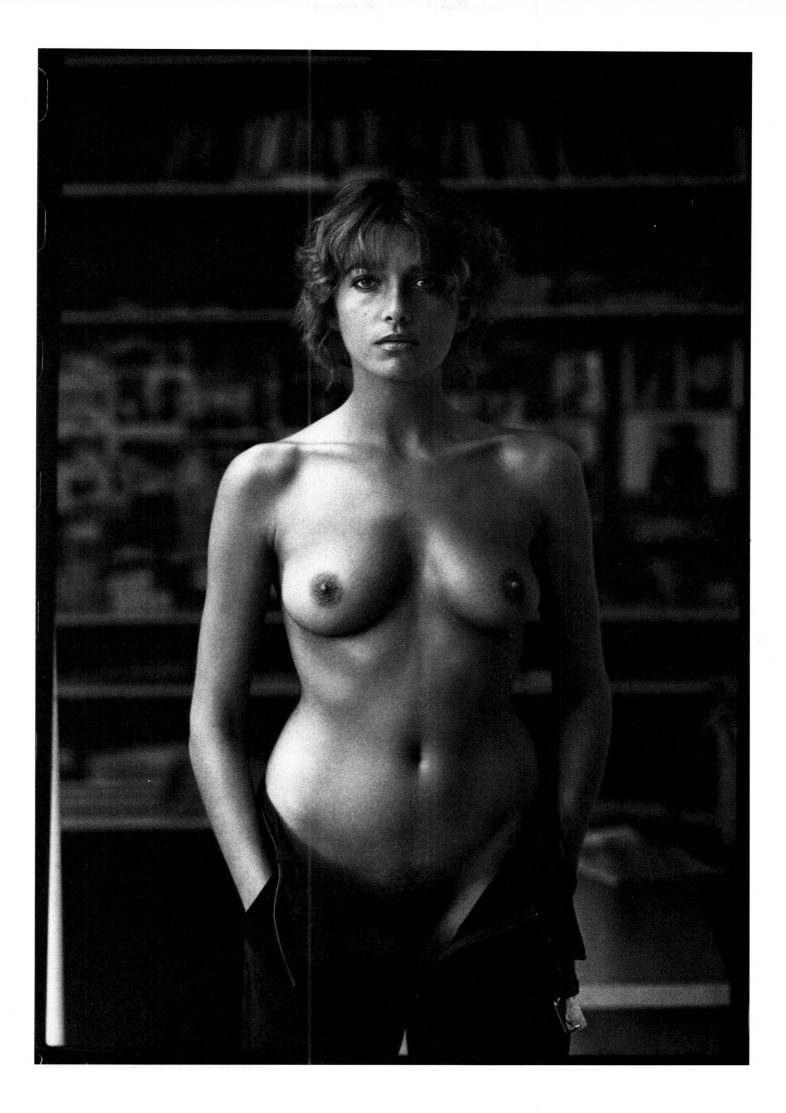

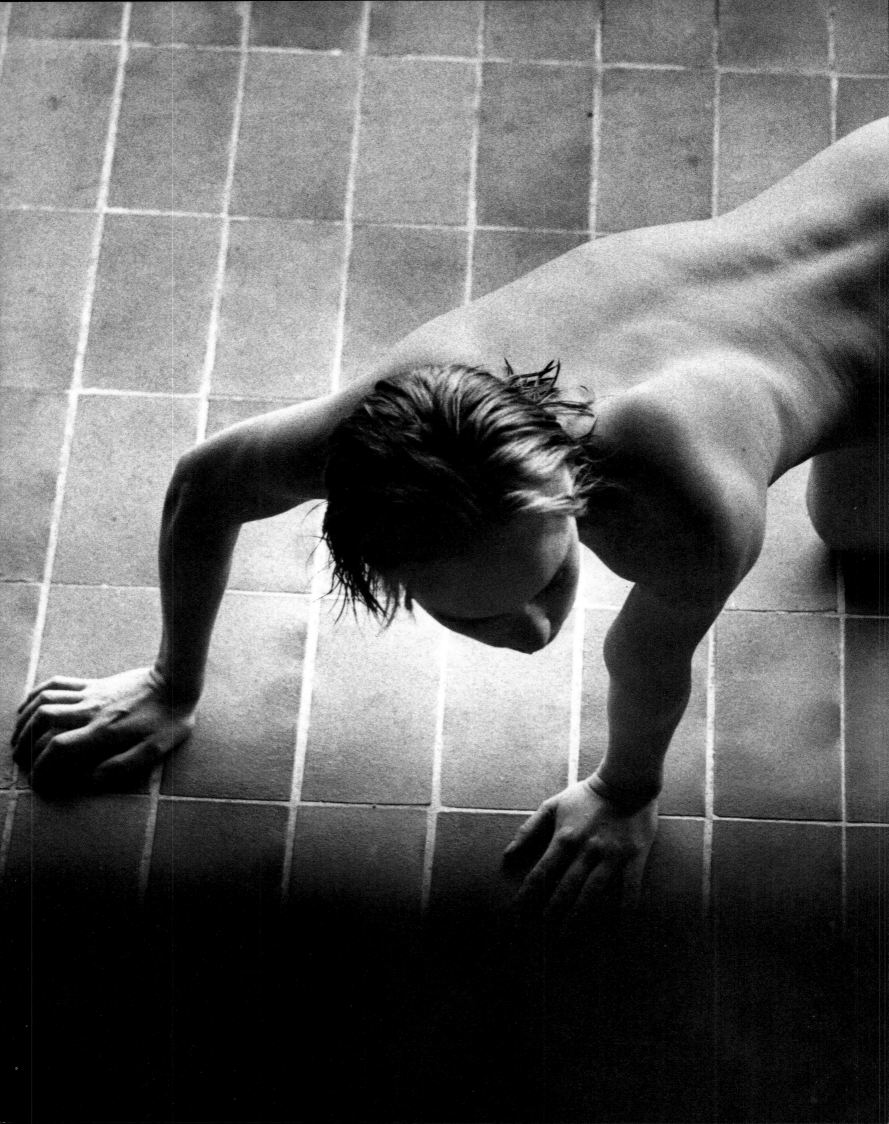

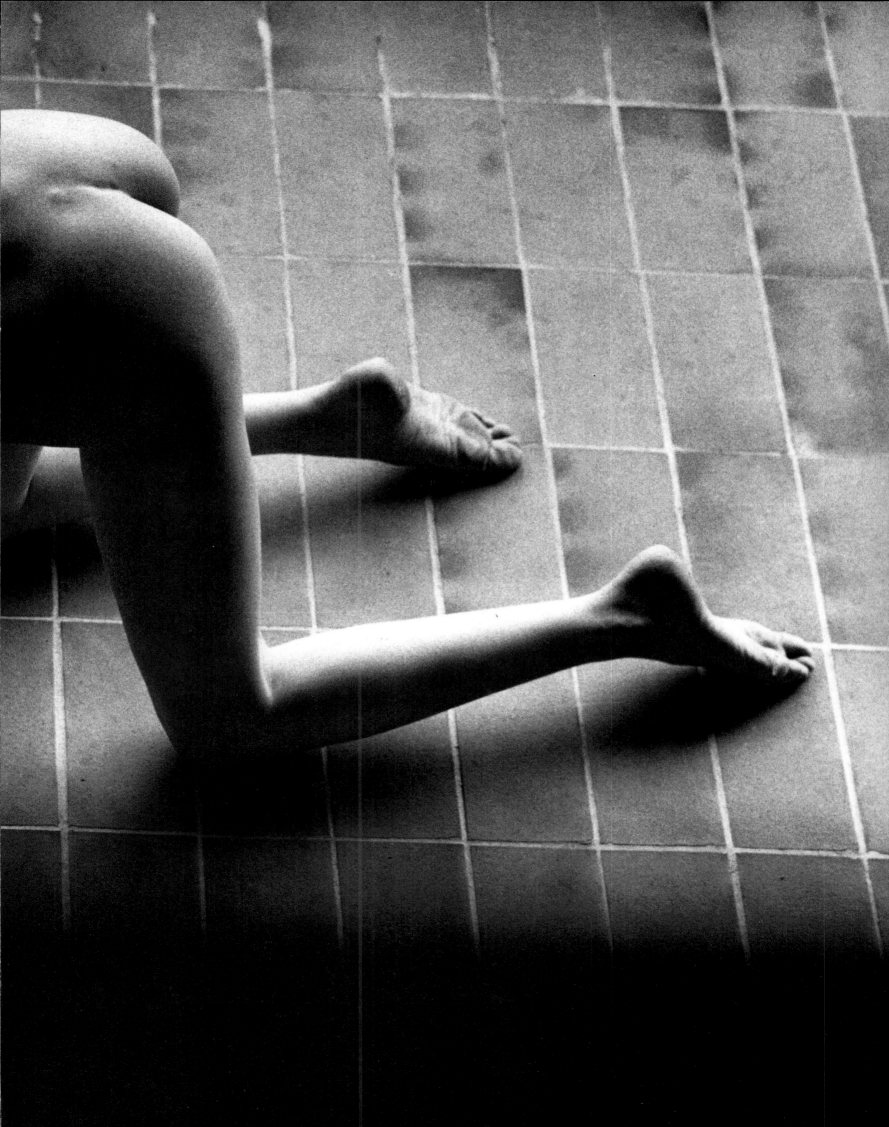

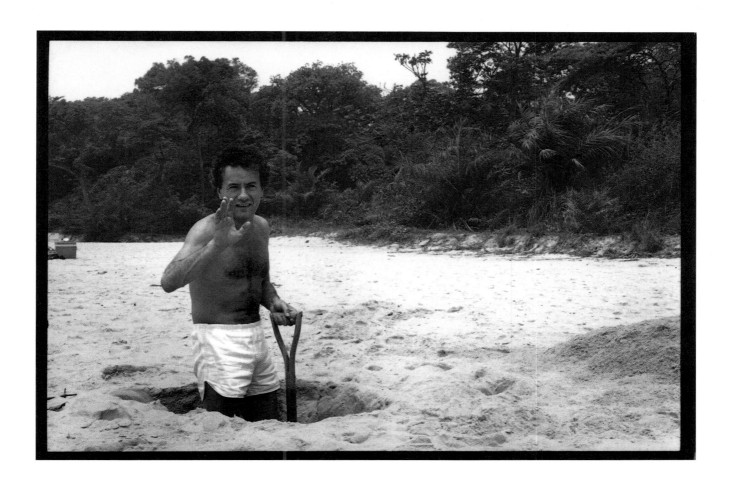

I WOULD LIKE TO THANK

first all the young girls and young women who
kindly spent a moment in front of my lens with me.

Then in no particular order:

LES FIDÈLES TRI-X
SIMONE VASSORT
JOURNAL PHOTO
VOGUE HOMMES
VOGUE ANGLAIS
JOURNAL STERN
HÔTEL WESTMINSTER AU TOUQUET
MAUD MARKER
BRUNO SUTER
GITANES SANS FILTRE
LE JUS DE POMME
GALERIES LAFAYETTE
COSMOPOLITAN
STUDIO ONNA
JEAN-JACQUES NAUDET
LA FAMILLE PUBLIMOD'
ALAIN MASSIO
LA S.N.C.F.
MARC GUIBERT
LE JARDIN DES MODES
JOURNAL FEMMES
JEAN-FRANÇOIS PIGNARD DE MARTHOD
MES JOYEUX NIKON FM-II
LES FILLES DE TANDEM
JACQUES BERGAUD
DÉA LECOINTE
GHISLAINE BOFFETY
ODILON V. LADEIRA
HERVÉ DE LA MARTINIÈRE
ÉRIC HISPARD
MARTINE LEBRUN-CAILLET

JEAN-LOU PRINCELLE FOR THE PHOTOS ON THE
ENDPAPERS
AND MAMAN, PAPA
LE LUBÉRON, PROVENCE

JUST TO NAME A FEW

ICH DANKE

zuallererst allen jungen Mädchen und jungen
Frauen, die sich freundlicherweise für einen
Augenblick vor mein Objektiv gestellt haben.

Dann in der Reihenfolge, in der sie mir gerade
einfallen:

LES FIDÈLES TRI-X
SIMONE VASSORT
JOURNAL PHOTO
VOGUE HOMMES
VOGUE ANGLAIS
JOURNAL STERN
HÔTEL WESTMINSTER AU TOUQUET
MAUD MARKER
BRUNO SUTER
GITANES SANS FILTRE
LE JUS DE POMME
GALERIES LAFAYETTE
COSMOPOLITAN
STUDIO ONNA
JEAN-JACQUES NAUDET
LA FAMILLE PUBLIMOD'
ALAIN MASSIO
LA S.N.C.F.
MARC GUIBERT
LE JARDIN DES MODES
JOURNAL FEMMES
JEAN-FRANÇOIS PIGNARD DE MARTHOD
MES JOYEUX NIKON FM-II
LES FILLES DE TANDEM
JACQUES BERGAUD
DÉA LECOINTE
GHISLAINE BOFFETY
ODILON V. LADEIRA
HERVÉ DE LA MARTINIÈRE
ÉRIC HISPARD
MARTINE LEBRUN-CAILLET

JEAN-LOU PRINCELLE FÜR DIE PHOTOS DER VOR-
UND NACHSATZSEITEN
UND MAMAN, PAPA
LE LUBÉRON, PROVENCE

UM NUR EINIGE VON IHNEN ZU NENNEN